GRAMERCY GREAT MASTERS

Vincent Van Gogh

Gramercy Books
New York • Avenel

Acknowledgments
The publishers would like to thank the museums for reproduction permission and in particular the BRIDGEMAN ART LIBRARY for their help in supplying the illustrations for the book.

Armand Hammer Foundation, USA: The Parsonage Garden in Winter.
Christie's, London: Peasant Woman; Brabant Landscape; Portrait of the Artist's Mother.
Rijksmuseum Kroller-Muller, Otterlo: The State Lottery; Agostina Segatori in Her Café du Tambourin; Café Terrace at Night; Pollard Willows and Setting Sun; Road with Cypresses.
Fogg Art Museum, Harvard University, Cambridge: Self-Portrait.
Glasgow Art Gallery and Museum, Glasgow: Le Moulin de la Galette; Portrait of Alexander Reid.
Hermitage, St. Petersburg: Portrait of Dr. Felix Rey.
Kunsthalle, Bremen: Poppyfields.
Kunstmuseum, Winterthur: Wheatfield with a View of Arles.
Musée d'Orsay, Paris: Pine Tree in Front of the Entrance to the Asylum; Restaurant de la Sirène, Asnières; The Italian Woman; Self-Portrait; The Dance Hall at Arles; Van Gogh's Room at Arles; Noon Rest (after Millet); Portrait of Dr. Gachet; The Church at Auvers; Vase with Flowers.
Museo de Arte de Sao Paolo: Portrait of Madame Ginoux (L'Arlesienne).
Museum Boymans-Van Beuningen, Rotterdam: Portrait of Armand Roulin.
National Gallery, London: Farms Near Auvers; Wheatfield with Cypresses.
National Gallery of Art, Washington: Mousme Sitting in a Cane Chair.
Neue Pinakotek, Munich: Vase with Twelve Sunflowers.
Phillips Collection, Washington: Entrance to the Public Gardens at Arles.
Paul Getty Museum, Malibu: Irises.
Private collections: Portrait of a Woman; Portrait of Père Tanguy; The Sower; Portrait of the Postman Joseph Roulin; Figure of an Angel; Portrait of Augustine Roulin (La Berceuse).
Pushkin Museum, Moscow: Fishing Boats at Sea; Prisoners' Round.
Stadtische Kunsthalle, Mannheim: Vase with Roses and Anemones.
Vincent van Gogh Foundation, Van Gogh Museum, Amsterdam: Wheatfield Under Threatening Skies.
Stedelijk Museum, Amsterdam: The Potato Eaters.

This 1994 edition is published by Gramercy Books,
distributed by Outlet Book Company, Inc.
a Random House Company,
40 Engelhard Avenue
Avenel, New Jersey 07001

Printed and bound in Italy

8 7 6 5 4 3 2 1

Vincent Van Gogh
His Life and Works

The life of Vincent van Gogh, who despite his fragile and troubled temperament strove unceasingly to express his powerful emotions, is inseparably bound to his art. His revolutionary style of painting was the fruit of a life devoted to the constant attempt to break free of his "prison of the soul" and was his only means of overcoming an intense interior solitude. In the end, however, the dark and somber genius himself became the victim of what had seemed to be the path to salvation, destroyed by the tyrannical omnipotence of his art. Although van Gogh's works were perhaps intended as a declaration of love toward the world and those people who rejected him, they are rarely "enjoyable" in the accepted sense. In his search for the deeper spirit of the subject he was portraying, van Gogh refused the compromise of superficially startling effects, creating instead pictures that are densely charged with emotional tension.

Virtually the whole of van Gogh's vast output, which includes more than eight hundred canvases and an enormous number of drawings and watercolors, seems conditioned by his desire to

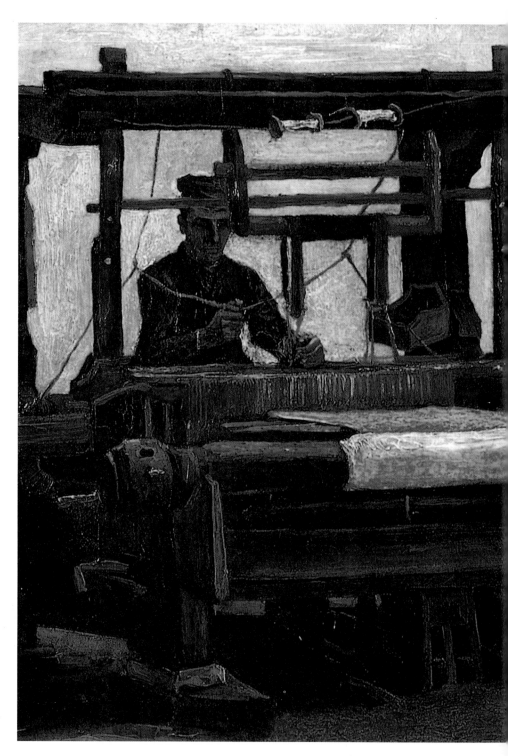

The Weaver
(detail)

understand a world that he saw as profoundly hostile. With this outpouring of his soul, with canvases pervaded by the tragic essence of existence, but also by unbounded hope for the future of humanity, van Gogh paved the way for the experimentation of twentieth-century painting.

Vincent Willem van Gogh was born in March 1853 in Groot Zundert, an isolated village in the Brabant region of the Netherlands. His father was a Calvinist minister; his mother, an energetic woman gifted with a loving and sensitive nature, was a valuable assistant to her husband in his pastoral duties. Vincent, the eldest of six children, spent his childhood amid cornfields and pine woods. Although he was a rather subdued and solitary child, for the rest of his life he would recall those early years with nostalgia. "During the illness," he wrote in 1889, "I saw once again every room of our house, every pathway and tree in the garden and even the magpie nest high up in the acacia of the graveyard."

Vincent attended the village school until he was thirteen, when he was sent as a boarder to a school run by Jean Provily at Zevenbergen. Although the town was only about fifteen miles from Groot Zundert, the separation from his home was difficult for the red-haired youth, who had little inclination for making new friends and missed terribly the safe and simple existence of family life.

His academic performance was far from satisfactory, and just two years later, van Gogh was sent even further afield to a school at Tilburg. His work did not improve and shortly afterward, in 1868, his father decided to withdraw him from school. Vincent, however, was by no means stupid. He read a great deal and was very perceptive, but he had difficulty concentrating on academic work. Nor did he show any particular talent for art at this stage, apart from a reasonable competence he displayed when he did some sketches of live models at Zevenbergen. When Vincent was hired as a sales assistant at the Dutch branch of Goupil, the famous Paris-based company of art dealers in The Hague, it was only through the influence of his Uncle Cent, who was an art dealer.

His employers were pleased with his work. They considered him to be diligent and eager to learn, and predicted that his career

would progress in a satisfactory manner. At the age of sixteen, Vincent's future seemed settled.

When the young man returned to his family for a holiday in the summer of 1872, he was able to establish a close relationship with his fifteen-year-old brother, Theo, who was four years younger and was to be enormously important in Vincent's life and in the evolution of his art.

In 1873, with the assistance yet again of Cent, Theo was taken on at the Brussels branch of Goupil, and the two brothers, sharing a mutual interest in their work, began the correspondence that constitutes an unintentional but fascinating autobiography of the artist. More than six hundred letters were exchanged over the years, and these provide profound insights into Vincent's spiritual and artistic tribulations. They trace the growth of the apparently quiet and contented youth into a man tormented by a desperate solitude. The letters depict an eternally vagrant soul whose only path out of the agony that beset him lay in painting, and describe how he strived to attain inner peace through this sublime declaration of love for humanity. Vincent's letters also illustrate the great spirit with which he applied himself to his work as an artist and reveal that even his considerable capacity for reflection failed to protect him from an almost naive lack of understanding of the mundane aspects of daily life.

In June 1873, Vincent was transferred to Goupil's London branch, a coveted appointment that was the reward for the conscientiousness shown in his previous position. The letters that Vincent wrote from London were still bright and carefree in tone. His appreciation of art became more substantial, and he often set down in rapid sketches what he observed during his long walks along the Thames River.

It was in London, however, that Vincent suffered his first serious rejection. He fell hopelessly in love with Ursula, the attractive daughter of his landlady. Unfortunately, Ursula's affections already lay elsewhere, and Vincent's incessant declarations were met with constant rebuffs. His mood darkened suddenly and he fell into a deep depression. The letters to Theo and his parents became less frequent and were filled with desperation. Once more Uncle Cent came to the rescue; he had Vincent temporarily moved to Goupil's

head office in Paris. But even here Vincent was unable to recover his emotional equilibrium. He visited the Louvre and the retrospective exhibition of Corot's works, but his interest in art and even in his own work seemed to have been blunted. The unease that perturbed van Gogh in this period could be attributed not only to his spurned ardor but also to a more general and pervasive reconsideration of his life, which was sparked by this first major disappointment.

Vincent returned to his work in London at the end of 1874, lodging once again in the house where his proposals of love had previously been refused. He became increasingly gloomy and withdrawn and was described for the first time as being "eccentric," according to Theo's wife, Johanna Bonger, who wrote a biography of her brother-in-law. One of the letters Vincent wrote to his brother at this time shows that he was experiencing a growing interest in religion.

In Paris, where Vincent was transferred once more by Goupil, he dedicated himself almost fanatically to the study of the Holy Scriptures. He seems to have regained a strong interest in art, but, rather paradoxically, this also had a detrimental effect on his work, for his pragmatic opinions on paintings led him to dissuade his customers from buying pictures that he personally disliked. At Christmas he left Goupil's without notice, and went to visit his parents' in their new home in Etten. His relations with Goupil became somewhat tense, and Vincent was dismissed early in 1876.

The following April, he returned to England again. There, in a working-class area of London, he was able to pursue his religious enthusiasms as a teacher and lay preacher. In the letters he wrote at this time, Vincent's ambition to enter the ministry as an evangelist became more evident. After a period spent as a bookseller in compliance with his parents' wishes, he managed to persuade his father of the earnestness of his religious aspirations, and in 1877 he went to Amsterdam to prepare for admission to the Faculty of Theology. This new undertaking, however, which he embarked upon with the same passion that he applied to all his activities, was doomed to failure. Vincent found the learned theological discussions difficult to endure, maintaining that they were superfluous for those like himself whose only aim was to "bring

peace to the wretched and reconcile them with their existence."

After abandoning his studies in Amsterdam, Vincent went to Brussels the following year, where he attended a series of simpler courses at the Evangelical School; but although the heads of the institute acknowledged his great preparation, they denied him a diploma as a lay preacher because of his "lack of submissiveness." Undeterred, Vincent moved at his own expense to the Borinage, a coal-mining region in Belgium, near the French border. In this inhospitable area he dedicated himself to help the downtrodden, first at Paturages, and then, with a temporary appointment from the Evangelical School of Brussels, at Wasmes, where the population consisted almost entirely of coal miners.

For fifty francs a month, van Gogh spread the word of the Bible and tended the sick. But he did not limit himself to these activities; identifying the poor and needy as manifestations of the suffering Christ, he gave them all his possessions, even his clothes, and was reduced to sleeping on a bed of straw in a crude hut. Despite this zealous application of religious principles, or more probably because of it, his superiors in Brussels refused to renew his appointment. This was another hard blow for Vincent, but he continued his mission alone, at Cuesmes, sustained by the extraordinary determination of his character, which was quite alien to compromise.

His family stood by him during this difficult time, particularly Theo, who nevertheless tried to discourage Vincent from pursuing his chosen career with such extreme ardor, sacrificing even the basic necessities of life. Theo suggested that Vincent reflect upon his life more deeply. Vincent was apparently offended by his brother's counsel and stopped writing to him for nine months. But he must have heeded Theo's advice, since in July 1880 he sent him a long letter analyzing his spiritual changes with unsparing candor, and announcing his decision to dedicate himself totally to art; in the future both his love of God and his social commitment would be expressed through the medium of painting. His preferred subjects in this period were miners on their way to the collieries and poverty-stricken workers. And to improve his technique, he copied the works of Millet and Breton, whose inner natures he felt to be very close to his own.

Thus it was that van Gogh found his vocation in the bleak region of Baronage, and art became the only field in which he would express his experiences, failures, and hopes. In September 1880, he went to the Academy of Fine Arts in Brussels. There, with the same uncompromising passion that he had applied to his missionary work, he dedicated himself to the study of anatomy and perspective, producing a ceaseless flow of drawings showing, above all, peasants and commoners portrayed in dark and somber tones in the manner of Millet. These drawings were mainly in pen and ink or pencil, but they were done on unbleached Ingres paper, enabling van Gogh to obtain fluid and shadowy outlines; his desire to progress from drawing to painting is clearly evident. Theo introduced him to the painter Anthon von Rappard, a fellow Dutchman, and the two artists became close friends.

In 1881, van Gogh moved back to his parents' house at Etten where for a while he enjoyed the company of Theo, by now a trusted employee of Goupil in Paris, a position that encouraged Vincent to appreciate his brother's opinion on his own work. At Etten, however, there was also his cousin Kate. She was recently widowed and had a young daughter. Vincent, with his typical impetuousness, immediately declared his love for her. His proposals became so pressing that Kate was forced to return to her parents in Amsterdam. Van Gogh followed her, in the vain hope of having his feelings reciprocated. This was the second great romantic rejection he suffered, and it was not to be the last; his inability to arouse the interest of the women to whom he was attracted was another important aspect of his difficulty in coming to terms with life, except in the realm of painting.

The disappointed young artist turned his renewed efforts to his work. Between November and December of 1881, under the guidance of the Dutch painter Anton Mauve, he produced his first paintings in oils, as well as several watercolor sketches of scenes.

The following year, Vincent moved to The Hague once again. There, with Theo's financial assistance, he set up his own studio. His paintings of this period are noticeably influenced by the Hague School, of which Mauve was a member, and Vincent showed great interest in the works of such artists as Weissenbruck and Willem Maris. Nevertheless, van Gogh's *Scheveningen Beach*, done in 1882,

already exhibits a leaning toward the abstract in the technique of applying the paint and in the variations of tone.

At this point, van Gogh came into disfavor with the leading exponents of the Hague School, although it is not certain whether this was caused by differences of artistic opinion or whether his colleagues disapproved of Vincent's private life. It seems that in one of his moments of impulsive idealism he had asked Clasina Maria Noornik to live with him, as his model and lover, quite probably in the hope of "redeeming" her. Clasina, known as Sien, was about thirty, a prostitute, had one child already, and was pregnant with another. In her pockmarked face, van Gogh recognized a fellow outcast of society, in dire need of affection. The relationship degenerated quickly. There were violent arguments until the couple separated, partly on the advice of Theo.

Vincent's art had by now acquired a definite orientation toward subjects drawn from observation of the humbler quarters of The Hague—commoners, peasants at work, and vagabonds. There is also a drawing of Sien from this period, *Sorrow*, showing her lean and emaciated body, by no means attractive but with great dramatic impact.

After leaving the Hague School, Vincent spent a short time at Drente, before moving on to Neuenen in the Brabant, where his father had been transferred. Van Gogh stayed here for two years, working indefatigably, to create his first works that were marked by a distinctly personal style. This was a fruitful period, with more than two hundred paintings and a vast number of drawings and watercolors. The themes were those preferred by van Gogh, but no trace of formality or artificial sentiment is evident in these peasants and laborers, only a harrowing attempt to express with violent brush strokes and dense, bituminous pigments the harshness of the human condition, ennobled nonetheless by the implicit dignity of honest toil.

In his *Weaver* of May 1884, Vincent portrays the protagonist totally engrossed in his work, behind the enormous loom that seems to have incorporated him into its massive structure. The picture expresses van Gogh's obvious identification with his subject; he frequently liked to think of himself as a simple worker who was crafting an object with his own hands, without being subjugated to the slavery of industrialization.

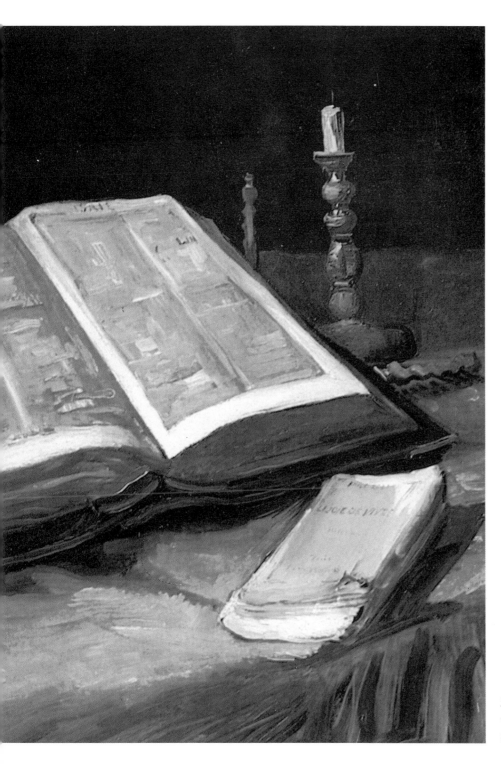

Still Life
with Bible
(detail)

Van Gogh's stance differed from the abstract compassion for the hardships of the working classes that was at the time greatly in vogue among intellectuals. He felt a much deeper-rooted sympathy toward socialist ideals and yearned to find his public in the very subjects that he depicted. He succeeded in this aim with the lithographs from *The Potato Eaters*. They were printed in an edition of twenty which he managed to sell at a low price to the peasants of his village.

The Potato Eaters is a work of great importance. Although it was influenced by the Dutch masters of the seventeenth century—as were all his works from this period—it is in many ways an expressionist canvas, both for its dramatic composition and for the hard lines used to portray the peasants seated around the table for their evening meal. It is without doubt the most representative work from van Gogh's period of fervent social commitment, although this phase was shortly to be superseded by more markedly pictorial interests.

After the death of his father, Vincent moved to Antwerp and sought to resume his contacts with the artistic establishment by enrolling in the academy of Antwerp, and also by studying under Franz Vinck. In *Still Life with Bible*, the last painting done at Neuenen before va Gogh's departure, a kind of testimonial to his previous artistic experiences can be detected, as can an allegory of the contrasting emotions of love and hate that he felt for his family's almost bigoted brand of Calvinism; the picture shows a Bible set opposite a copy of Emile Zola's *La joie de vivre*, symbolically representing naturalism.

The van Gogh who worked in Antwerp, however, was by no means a confident painter sure of his future direction. During the relatively serene years spent at Neuenen, Vincent was subject to a continuous state of depression, and the death of his father had provided yet another violent jolt to his already fragile emotional state. Fortunately, the city of Antwerp offered the works of Rubens; van Gogh was highly impressed by these, above all by the master's great capacity to paint "with a rapid hand and without hesitation." Applying himself once more to his studies, van Gogh acquired a more fluid handling of his brushes and learned to use a wider range of colors. His earliest period, dominated by somber

and melancholic themes, seems to have been put behind him, and he became a more vivacious painter intent on experimentation.

In March 1886, Vincent went to Paris and stayed with Theo, who, having become a stalwart supporter of modern art, was able to introduce his brother to some of the Impressionists, including Monet, Degas, Renoir, and other leaders of the movement. These painters had a brief influence on Vincent's palette, although his fundamental autonomy of expression was always evident in his numerous self-portraits and still lifes of this period. At times, however, van Gogh draws noticeably close to the Impressionists. While pictures like *Self-Portrait with a Felt Hat* still seem linked to a more northerly style, in *Agostina Segatori in Her Café du Tambourin* the colors are irresistibly lively and the brushwork delicate and quick. Agostina Segatori had been a model for Degas and was the proprietress of the Café du Tambourin, where van Gogh spent much time and later organized a small exhibition. Vincent was living with Theo at this time, and he seemed to find a certain equilibrium in the bohemian life that he shared with the Impressionists.

Of the works done in 1886 and the following year, particularly important is *Interior of a Restaurant*, in which van Gogh uses a personal interpretation of the pointillist techniques of Seurat. In *Four Sunflowers*, the petals seem to burst out in prelude to the flamelike shimmer of the cypresses that he would paint later at Saint-Rémy. The series of Japanese pictures, including *Plum Blossoms* and *Bridge in the Rain*, were inspired by the works of Hiroshige, greatly in fashion in contemporary Paris. But perhaps the painting that best represents van Gogh's period in the French capital is the famous *Portrait of Père Tanguy*. In this picture, Julien Tanguy, a familiar figure to the Impressionists, is depicted in the foreground facing outward, without being separated in any way from his surroundings. Van Gogh was evidently quite willing to sacrifice the objective reality of the scenes he painted, if he could concentrate on the representation of the interior world.

In the meantime, his relations with the Impressionists grew cooler; Vincent's impulsive and tenebrous character prevented him from renewing a peaceful relationship with his fellow painters after their heated discussions on art, which were always mediated by

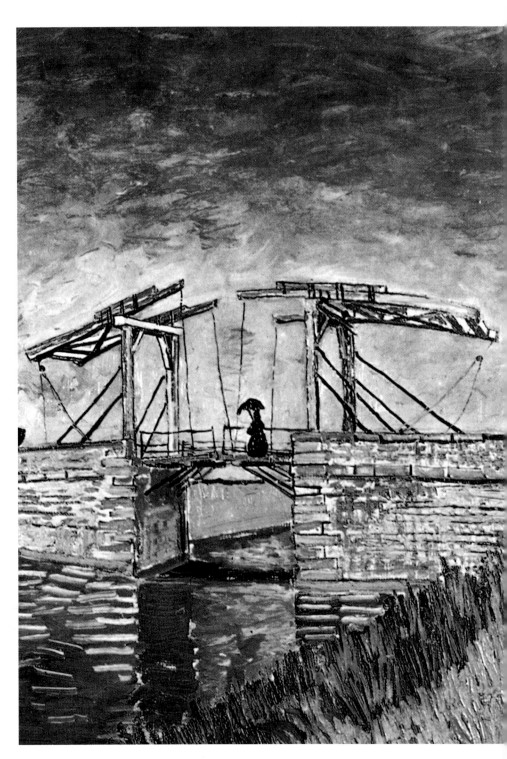

Langlois Bridge
(detail)

the presence of the wine bottle. Van Gogh had never really been an intimate part of the Impressionist circle, whose members managed to get along well despite their frequent differences of opinion. In addition, it was impossible for the Impressionists to accept van Gogh's work as truly representative of their movement. He rarely used separated dabs of color, preferring short and vigorous brush strokes that contrasted or combined to form a kind of harmony, which was nevertheless imbued with great energy.

By the end of his period in Paris, van Gogh had become the sole exponent of a highly individual language, a synthesis of elements from all the various styles that his tenacity had led him to investigate. But once again he was an outsider, rejected by his contemporaries despite his fervent desire to develop ideals that would be recognized by the movement into which he had made a brief excursion, and inspired by the idea of a community of artists working side by side. This project was to be yet another source of rejection for Vincent.

Deeply disappointed by his acquaintances in Paris, Vincent decided to move to the south, as Cézanne had done earlier, in search of warmer qualities of light and the richer colors that nature could offer. When he arrived in Provence, in February 1888, he found snow awaiting him and, fortunately, he was greatly impressed by the scenery.

Having taken up residence in Arles, at the Hotel Carrel, he wrote to his sister: "I have no need of Japanese art here, as I tell myself I am in Japan already." In *Peach Blossoms*, painted shortly afterward, van Gogh's joy at the imminent approach of spring can be seen along with a number of themes prominent in the art of the Far East, or at least corresponding closely to the concept that the painter had formed of this art.

While Theo managed to have three of his brother's canvases shown at the Salon des Indépendants in Paris, Vincent was hard at work in Arles. In a mood of creative ecstasy, he roamed the Camargue, through the cornfields and vineyards of La Crau, painting blossoming orchards, harvest scenes, and anything else that reflected his intense feeling for nature. The two versions of *Langlois Bridge*, considered masterpieces of van Gogh's art, show the great character that had developed in his style and his enormous emo-

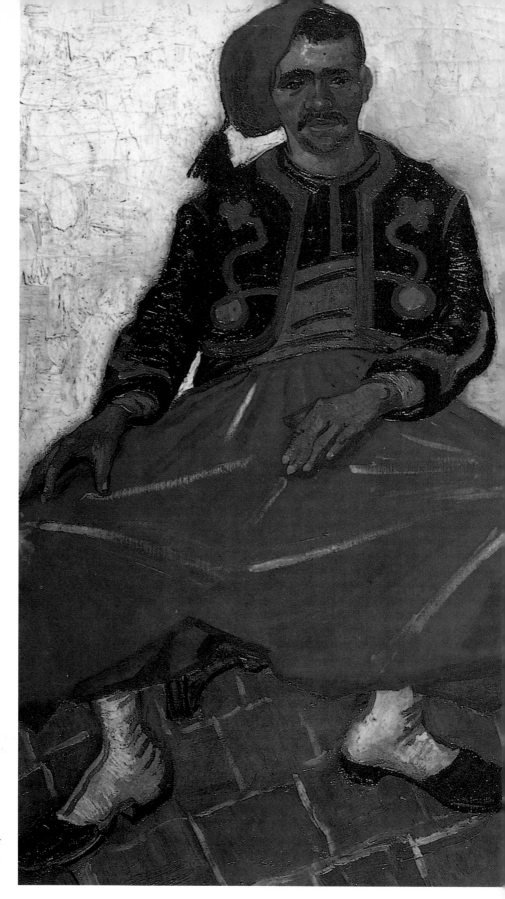

Portrait of a Zouave (detail)

tional participation in the scenes he painted. He evolved a new concept of tonality in painting, in which color no longer had a close relationship to reality but served only to illustrate the reality that lay in his innermost soul. This can be clearly seen in *Harvest* and *Starry Sky Above the Rhône*. As van Gogh's art moved ever further away from realism, to explore what Heidegger would later call "the intimate essence of things," the effects he achieved were powerful, and the distinctiveness of the backgrounds added emphasis to the objects he portrayed.

In this period, Vincent was full of an inspired fervor, and perhaps it was only because of this that a safe distance could be maintained between the artist and the symptoms of the mental illness that had always assailed him and during this time of frenetic work threatened to become more disturbing.

Van Gogh seemed full of optimism and rented a room over a café, as well as a house—the famous "yellow house," which he intended to use as a studio. His relations with others were far from easy. The people of the town felt a certain diffidence toward this silent stranger with such an unusual profession, which, above all, seemed to provide him with little economic security. Vincent found it difficult to find models willing to pose for him, and it was therefore with great pleasure that he painted the picture of an Algerian infantryman, an exotic subject recalling those found by Delacroix in Morocco. In the *Portrait of a Zouave*, done in June 1888, van Gogh seems to have concentrated his attention on the face of the soldier, and the military uniform is merely a decorative adjunct. The background has been sketched in rapidly, in a summary fashion, true to van Gogh's axiom that, in portrait painting it was necessary to "strike while the iron is hot."

During the summer, van Gogh painted two other portraits, *Mousme Sitting in a Cane Chair*, a lyrical image of adolescence that he successfully instilled with the atmosphere of a Japanese print, and *Portrait of the Postman Joseph Roulin*, showing one of the few people with whom the painter associated. These canvases reveal the intense sensation of identification that van Gogh shared with his subjects, symbolic of his unceasing attempts to forge a contact with humanity, which despite his persistence, or perhaps because of it, was always denied him. From the pictorial point of view, in

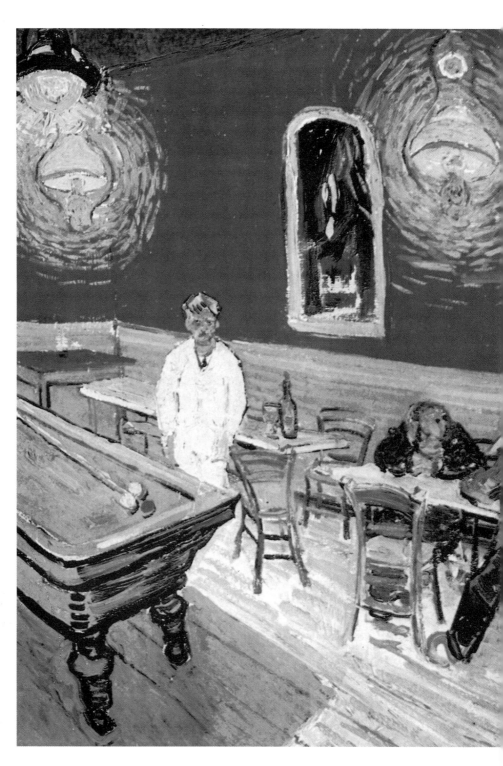

The Night Café
(detail)

the portrait of Postman Roulin, van Gogh seems to have temporarily abandoned his Parisian experiences, opting for a return to the technique of tonal variations around a single color.

Another work from the same period is *Fishing Boats at Sea*, which once again reflects van Gogh's propensities toward oriental art; but there is also the very personal element of a strong and luminous color that dominates the intellectual aspects of experimentation.

In September 1888, van Gogh painted *The Night Café*. This was an attempt to resolve the problem, by no means new to the world of figurative arts, of representing a nocturnal scene with a satisfactory rendering of the colors generated by shadows and artificial light. He came to this area of experiment quite by chance, inspired by a nighttime stroll near the sea that particularly impressed and stimulated him. Nevertheless, the nocturnal paintings of cafés are tinged with more than a hint of pessimism, revealed in part by his choice of colors, with contrasting reds and greens, and a lemon-yellow light that illuminates figures sunk in desolation. "The café is a place where you can ruin yourself, go mad and commit a crime," wrote van Gogh, showing the agonized empathy for the human condition that perpetually characterized him. The second painting in this series, *Café Terrace at Night*, was more properly nocturnal, being set outdoors, and van Gogh's experimentation produced remarkable results that greatly pleased him, encouraging him to continue with such subjects until the end of his days.

The year 1888 was indeed prolific, and in November van Gogh produced two more noteworthy portraits, *L'Arlésienne* and *Portrait of Armand Roulin*. In the first of these, he used the technique of *cloisonnisme*, the name of which was derived from a French word meaning "divided." This approach was typical of Gauguin, but was also used by many Symbolist painters, and consisted of surrounding every object with a distinct outline. This is precisely what van Gogh did in his portrayal of *L'Arlésienne*, a certain Madame Ginoux, and in several other works, but in such cases the outline was the result of a specific theoretical concept of painting, and he used the technique only when it was called for by the work. The second portrait, of Armand Roulin, demonstrates again Vincent's talent for enriching his work with warm tones of humanity when

he feels a particular affection for his subject. The Roulin family were the only neighbors with whom he had anything more than a mere nodding acquaintance.

Just a month before, in October, Paul Gauguin had joined Vincent at Arles. His arrival was partly due to the generosity of Theo, who now found himself burdened with the support not only of his brother, but also of Gauguin, who was in financial difficulties. Vincent, however, welcomed this new arrangement with great enthusiasm. Unfortunately, Gauguin, although he did share his host's concept of an ideal community of artists, had little esteem for the rather eccentric Dutchman.

Gauguin received a cordial welcome at the yellow house, which was newly decorated for the occasion. The famous paintings of sunflowers, so closely linked to van Gogh's subsequent reputation, were nothing more than ornamental pictures intended to brighten up the rooms where his friend was to stay, to be followed, as Vincent hoped, by other painters.

Van Gogh had sincere admiration for Gauguin, to the extent of assuming the role of pupil in their relationship. It is therefore not surprising that he used some of Gauguin's techniques, as in the *L'Arlésienne*. In their endless discussions on art, however, the two painters always ended up at diametrically opposed viewpoints. Gauguin found van Gogh excessively impulsive, while Vincent believed his friend's work to be influenced by a surfeit of mental preparation. Perhaps the differences between the two were the result of a basic incompatibility of character. Van Gogh's affection for Gauguin was certainly genuine, even to the point of an overwhelming possessiveness; he was obsessed with the terror of losing Gauguin and with him the last hopes of establishing a community of artists.

In two paintings of this period, *Van Gogh's Chair at Arles* and *Gauguin's Chair at Arles*, Vincent showed a pair of empty chairs, and succeeded in representing not only the differences between the personalities of the two artists—Vincent's chair is much more spartan, but with brighter, sunnier colors—but also his fear of solitude, or his awareness of the inevitable collapse of all his hopes that the departure of Gauguin would have provoked.

This permanent state of tension could lead only to tragedy. One

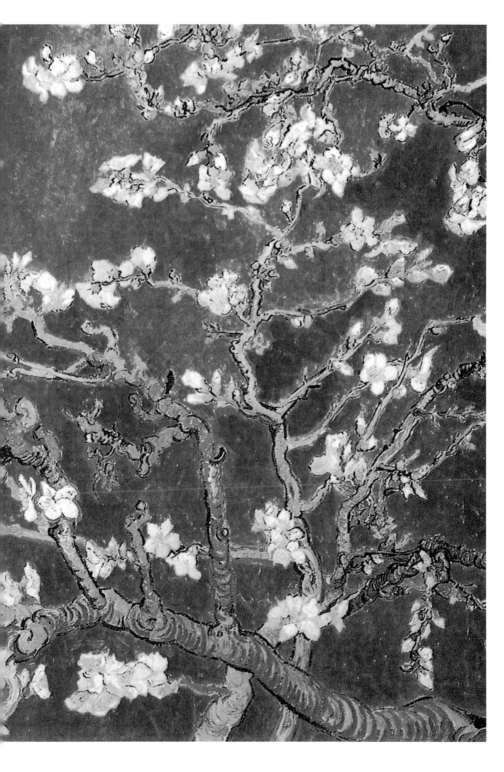

Almond Blossoms
(detail)

night in December, perhaps after having threatened Gauguin with a razor, Vincent sliced off the lobe of his left ear, wrapped it in a piece of paper, and presented it as a grotesque gift to a prostitute. He then went home, where the police found him asleep and bleeding profusely. While Gauguin made a hurried departure, Vincent was taken to Arles Hospital, where he stayed for two weeks. Returning home, he painted the celebrated *Self-Portrait with Bandaged Ear*, in which he is wrapped in a heavy overcoat, as if to protect himself from the outside world. His dreams of a community of artists had now been shattered: "After what has happened to me, I shall never dare to persuade other painters to come here," he wrote to Theo early in 1889.

A short time after this episode of self-mutilation, a petition signed by the citizens of Arles forced Van Gogh to return to the hospital, where he stayed until the beginning of May. Nevertheless, he continued painting, with more sunflower pictures, self-portraits, and a series of views of his new surroundings, including *The Courtyard of Arles Hospital*, a work in which it is difficult to detect any concrete hint of the artist's desperation. Perhaps he was becoming gradually resigned to this existence, and he began to consider the possibility of having himself voluntarily committed to the asylum of Saint-Rémy, a decision that he was able to implement in May 1889.

In no way, however, did van Gogh intend to abandon painting. On the contrary, accustomed as he was to accepting "madness in the same way as any other illness," he felt he was taking a necessary precaution to avoid the risk of losing his artistic abilities. The orderly life that he was forced to lead does seem to have had a beneficial effect: he was allowed to leave the asylum, accompanied by an attendant, so that he could dedicate himself once more to his painting, the only activity that still provided a link with the realities of life. His works at this time included *Two Cypresses*, characterized by a frantic rhythm of brush strokes laden with emotion, and *The Starry Night*, a nocturnal picture that also shows cypresses. Van Gogh thought them "as beautiful as Egyptian obelisks," and his trees reach up like spurting flames toward a sky populated by miraculous spirals of light. Also from this period is *Irises*, in which he exploits the sheer power of light, albeit to a less-

er degree than in *The Starry Night*, succeeding with such great effectiveness in expressing the passions that moved him.

In July and December of 1889, Vincent was again affected by violent crises that left him totally exhausted. But he returned undaunted to his work, and by the end of the year had even produced a score of small paintings inspired by the works of Millet. In February of the following year, he produced *Almond Blossoms*, intended as a gift for his nephew, the son that Theo had christened with Vincent's name. The picture shows a self-control unusual in his late works, and features perhaps the most luminous shades of blue that van Gogh ever used. By May 1890, Vincent had recovered sufficiently to visit his brother in Paris. He seemed to enjoy a reasonable serenity, but he must have painfully realized that by now Theo was able to dedicate much less time and attention to him. He moved on to Auvers-sur-Oise, the home of Dr. Gachet, a friend of many of the leading Impressionists and himself a painter, who had declared himself willing to care for van Gogh.

Vincent was stimulated by the diversity of his surroundings with respect to those of Provence, and immediately set to work on a series of canvases, including *The Church at Auvers*, one of his last masterpieces, painted with vigorous but orderly strokes. The blue of the sky sheds an impalpable light on the church, and the whole composition has a dreamlike quality. This was followed by *Portrait of Dr. Gachet*, in which van Gogh uses once again the rippling style developed at Saint-Rémy; and in July, the work that symbolizes van Gogh's pictorial universe and was his spiritual testament, *Wheatfield Under Threatening Skies*, was painted, a canvas that vibrates with a fury of expression in which a veritable cry of anguish can be heard with remarkable clarity.

Vincent's condition deteriorated, and his letters show that he was in a constant state of excitation. On July 27, he left the boarding house of the Ravoux family, where he was staying, and went into the fields with his canvas and brushes. But in the grip of yet another crisis, he decided to bring his tormented life to an end, and shot himself in the stomach. Despite the wound, he dragged himself back to his lodgings, where he died two days later in his brother's arms. "I risk my life for my work, and my reason has almost been wrecked": these are the words of Vincent's last letter,

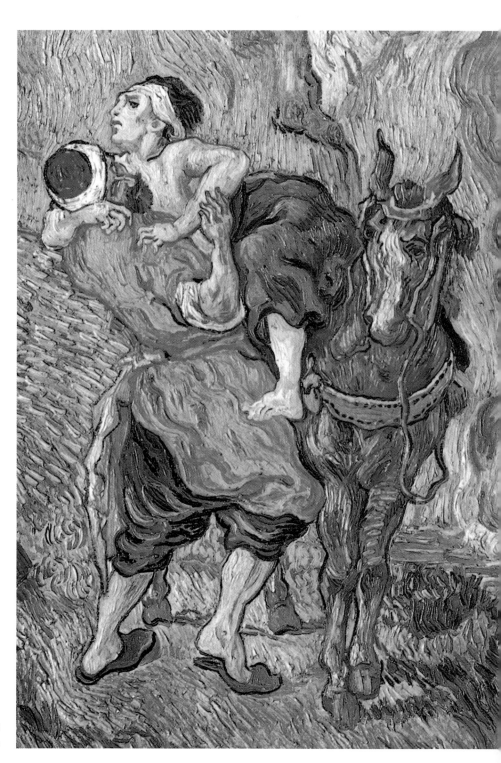

The Good Samaritan
(detail)

found in his pocket on July 29, 1890. Six months later, Theo followed his brother to the grave. They lie buried side by side in the cemetery of Auvers, surrounded by the cornfields that Vincent van Gogh so dearly loved.

Van Gogh is one of the most fascinating individuals in the history of art. The existential crises that he suffered seem to epitomize the cliché of the tormented artist that is so much a part of popular romantic imagery. Rarely has a painter met with such a total lack of interest during his lifetime, even from fellow artists by no means lacking in perception, and then achieved such an immense fame and complete revaluation after his death.

Critics now agree that van Gogh, despite his troubled life, or perhaps even because of it, was able to create a highly individual style of chromatic harmony that was hitherto unknown, and in the same way to invent the sinuous forms that are his hallmark, forms that symbolize his yearning to break free of artistic conventions. In addition to opening a new direction that would later be followed by the Fauves and the expressionists—of which some critics claim he was the first exponent—van Gogh has left works of absolute perfection, examples of an artistic commitment pursued to the very depths of desperation, and for which the ultimate price was self-destruction.

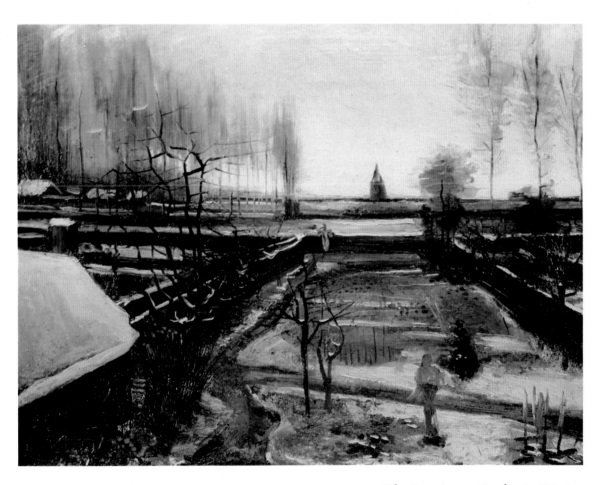

The Parsonage Garden in Winter

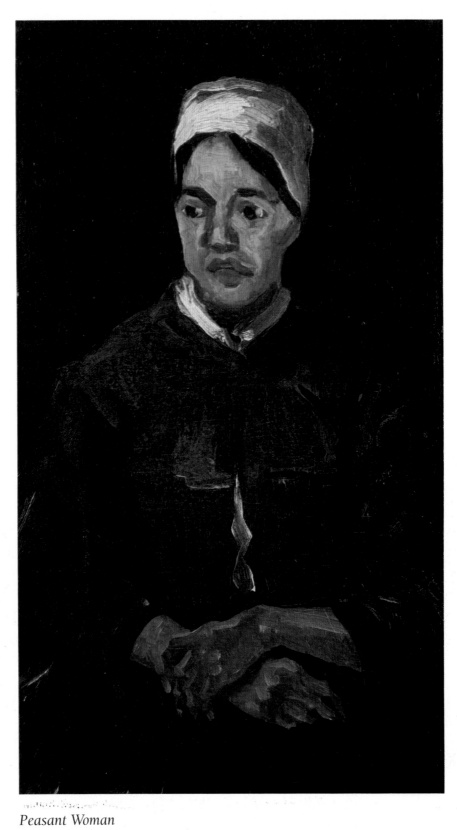

Peasant Woman

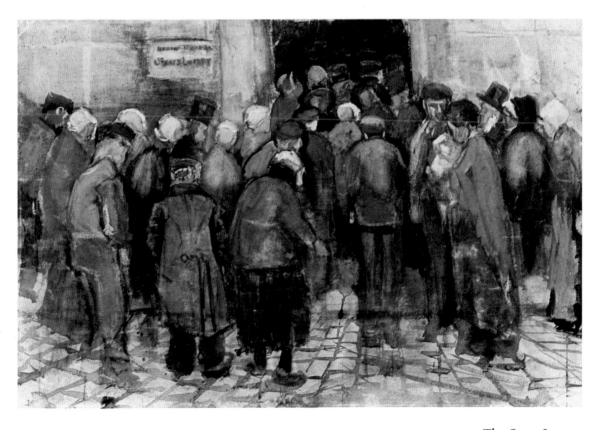

The State Lottery

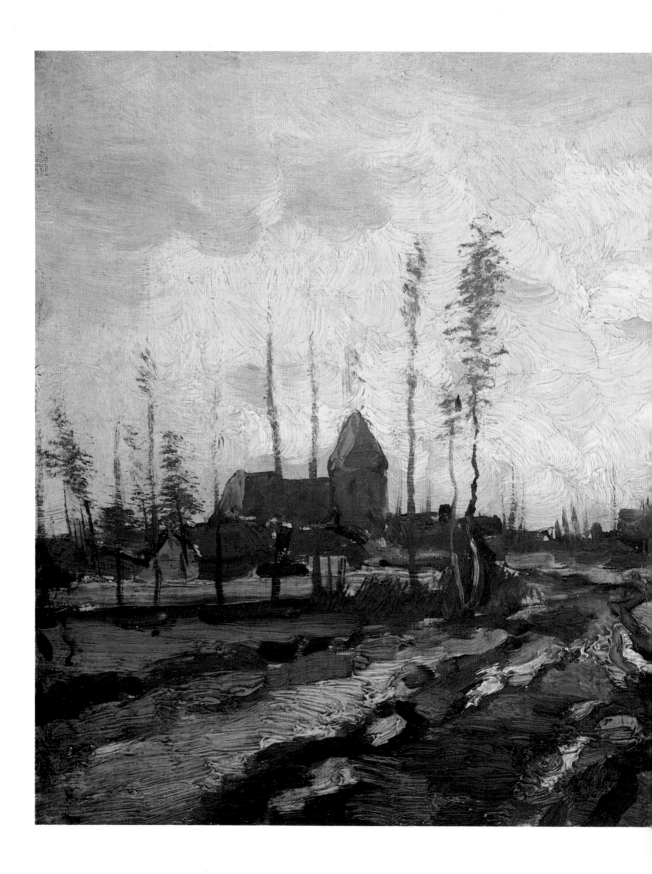

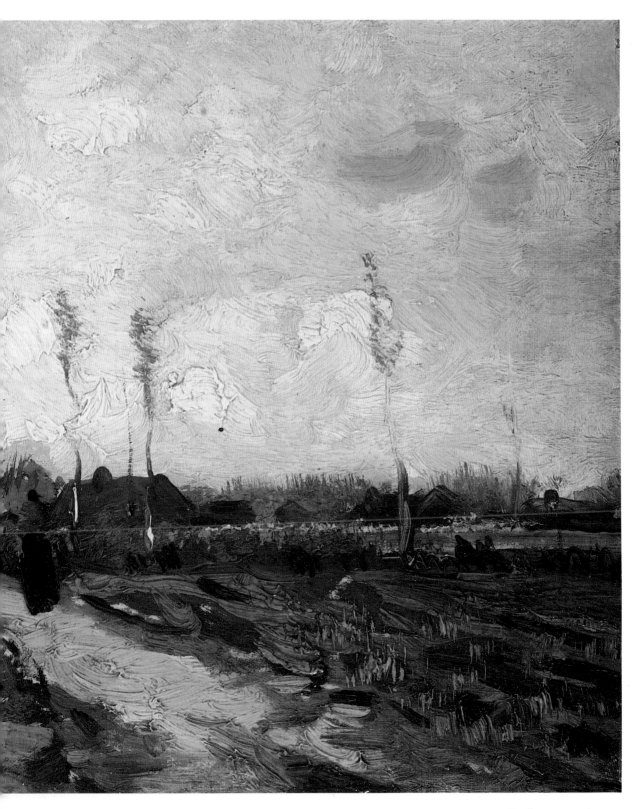

Brabant Landscape

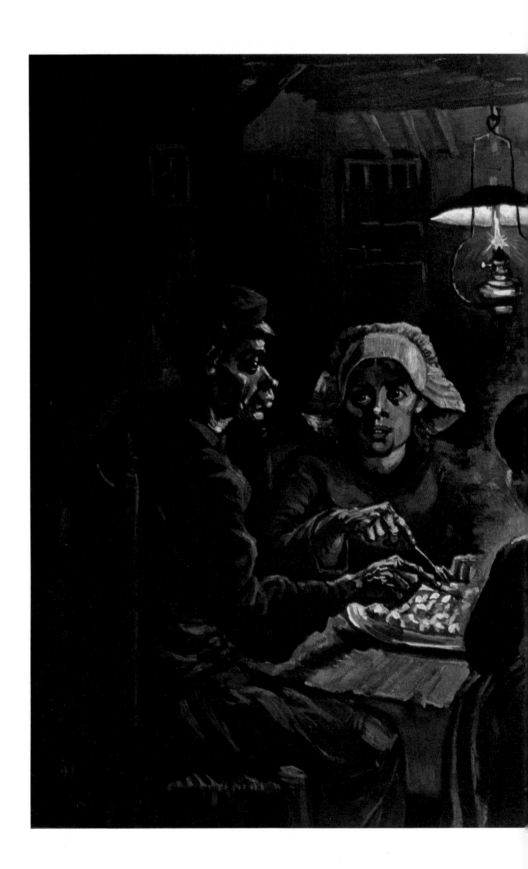

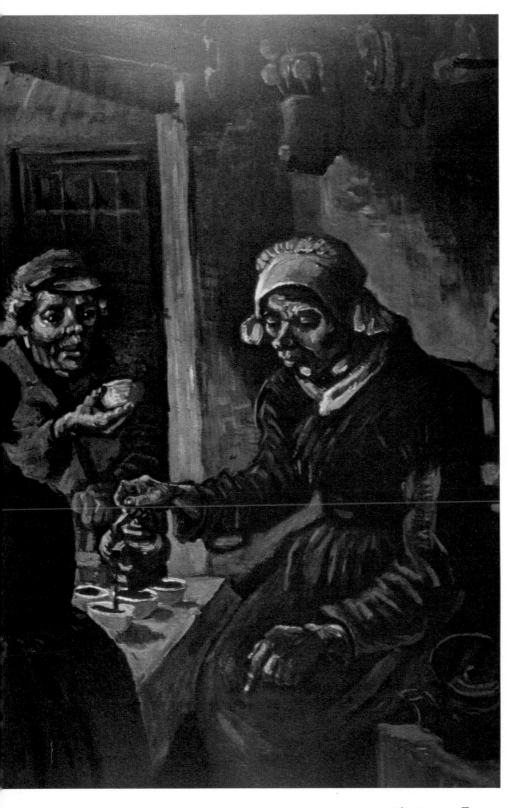

The Potato Eaters

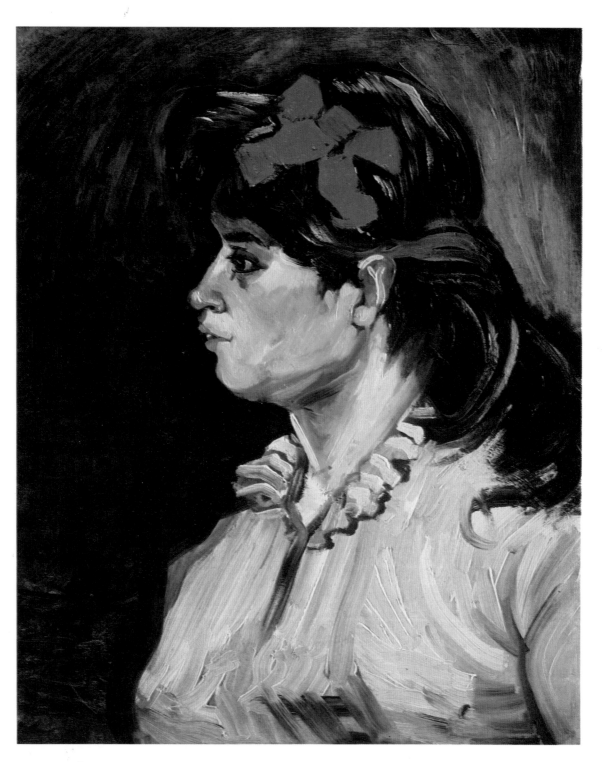

Portrait of a Woman

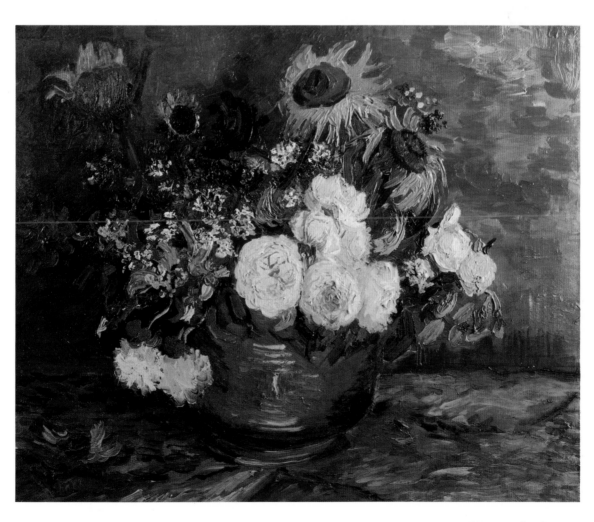

Vase with Flowers

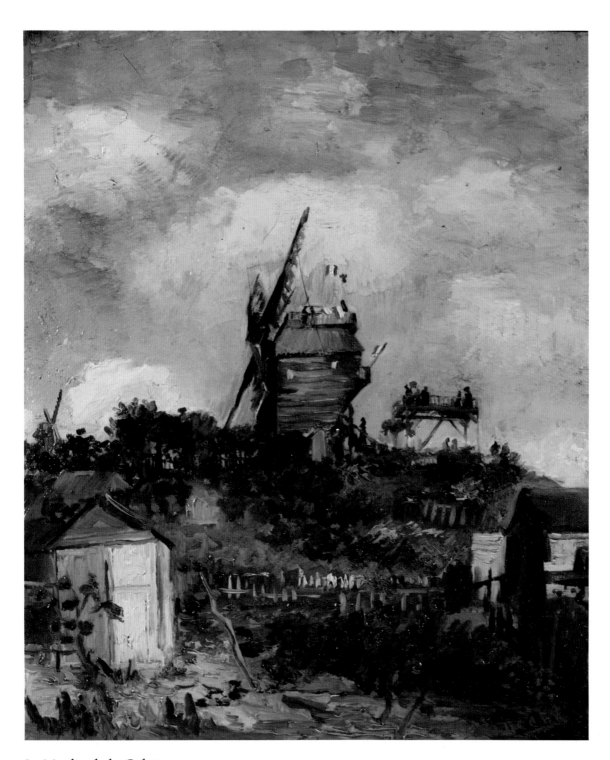

Le Moulin de la Galette

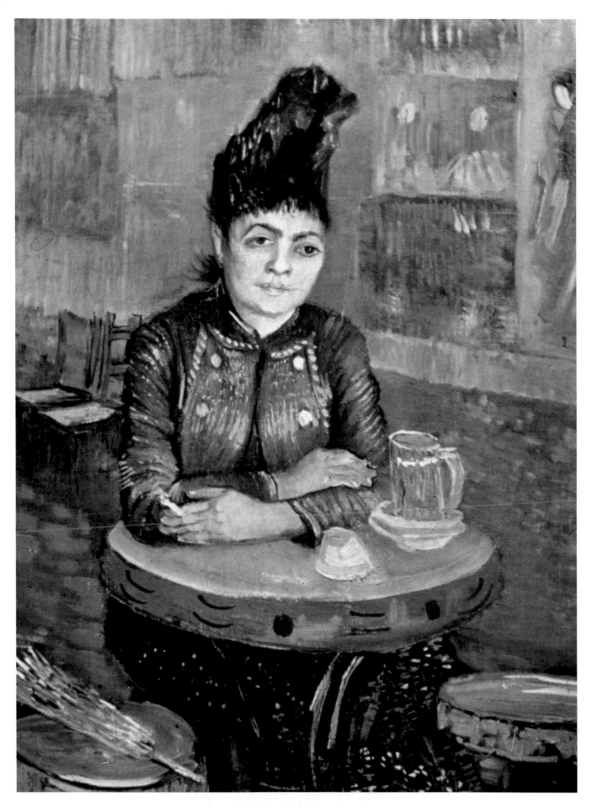

Agostina Segatori in Her Café du Tambourin

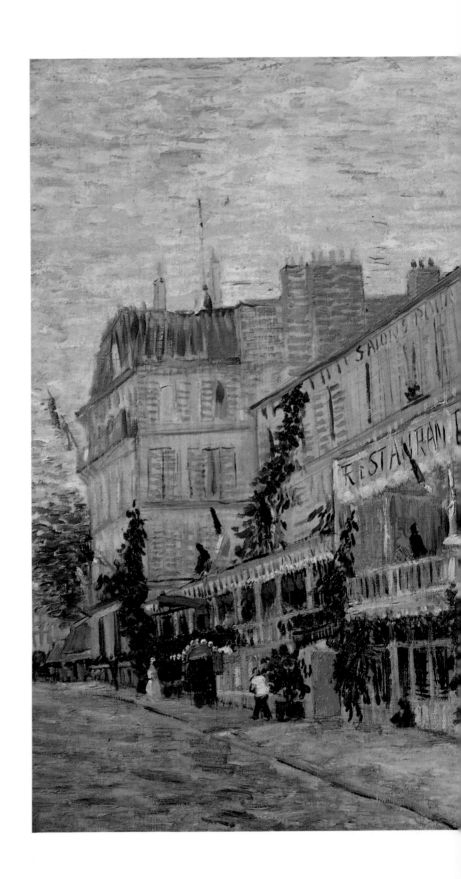

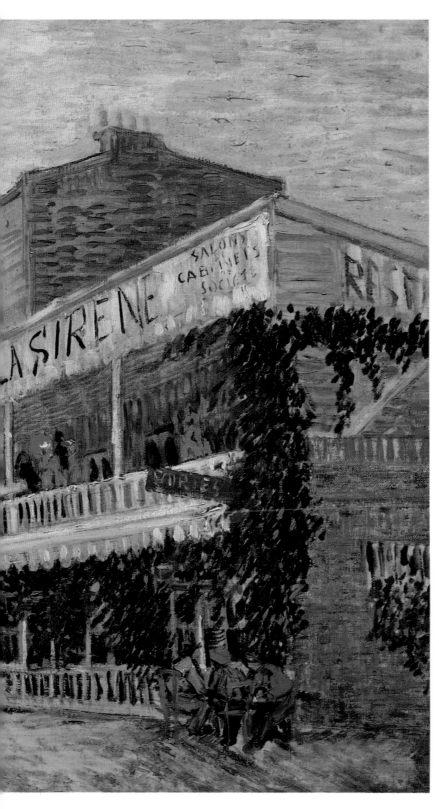

Restaurant de la Sirène, Asnières

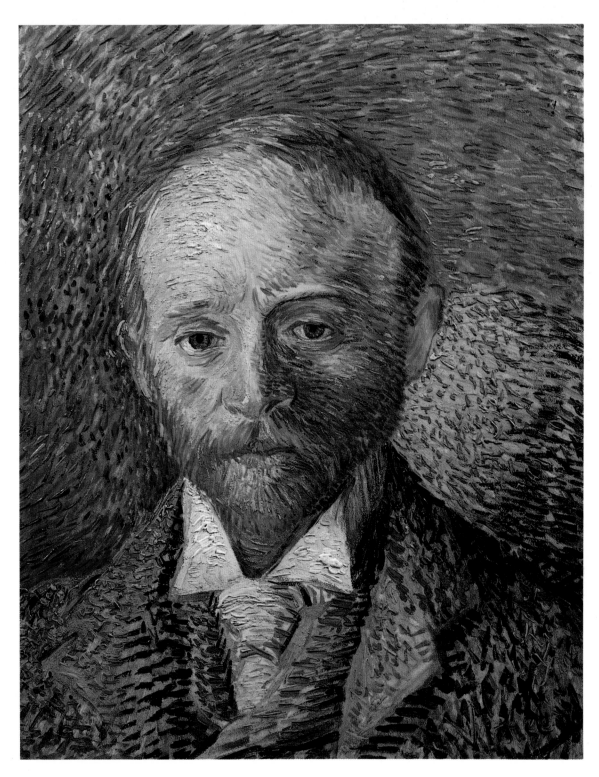

Portrait of Alexander Reid

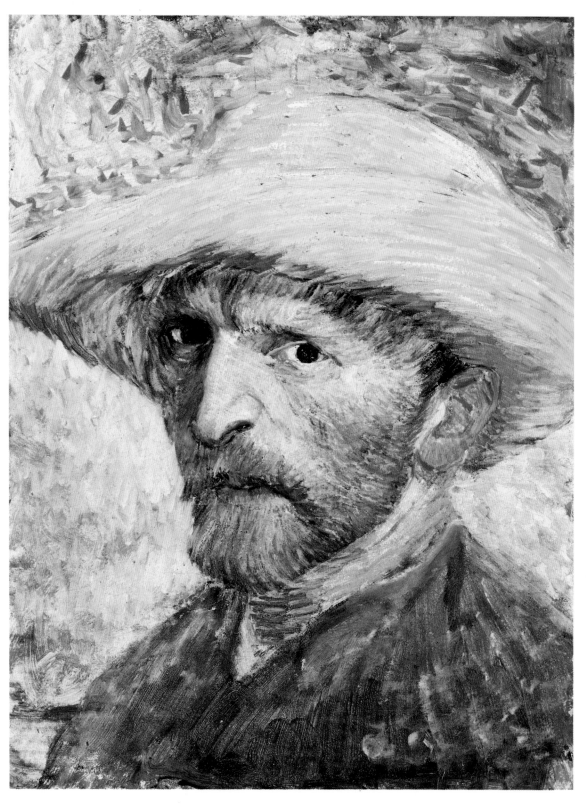

Self-Portrait

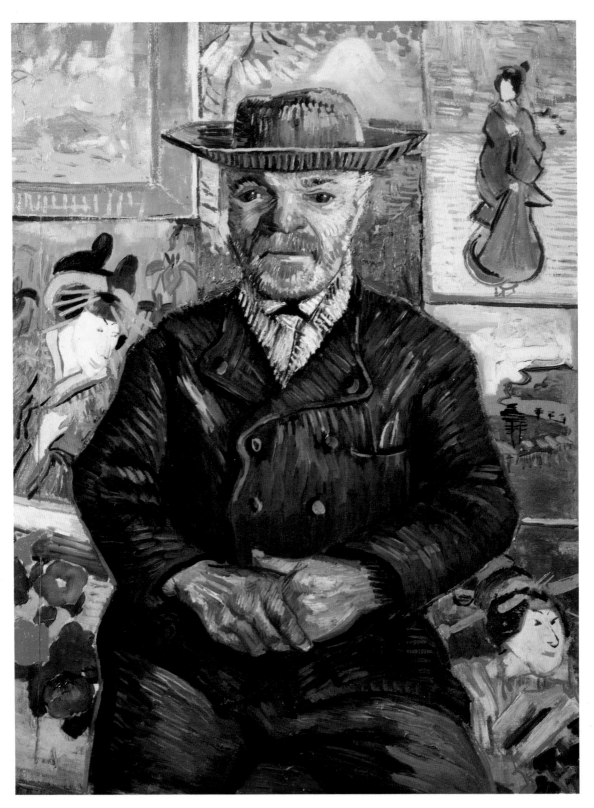

Portrait of Père Tanguy

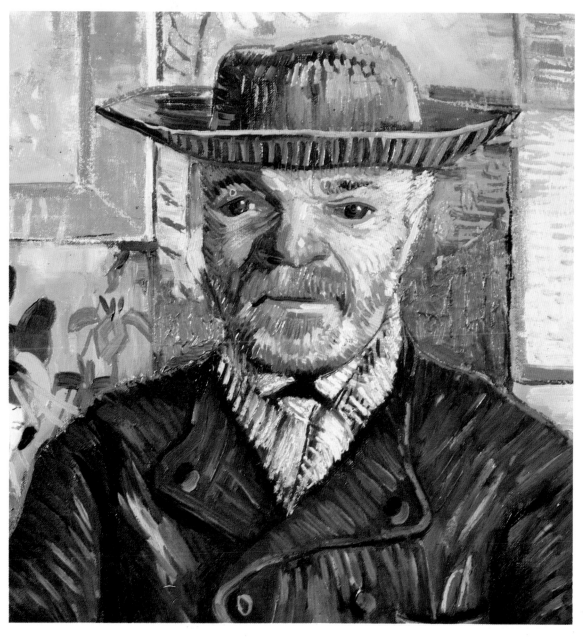

Portrait of Père Tanguy (detail)

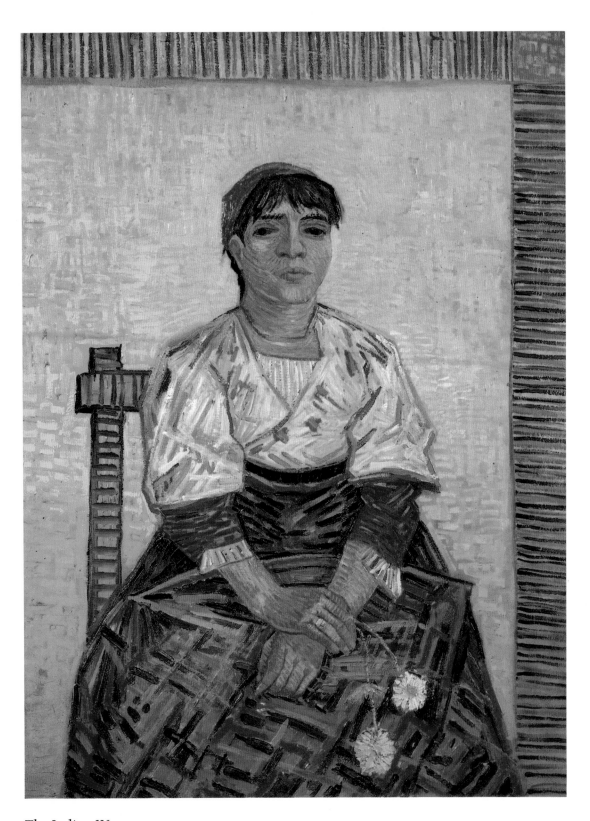

The Italian Woman

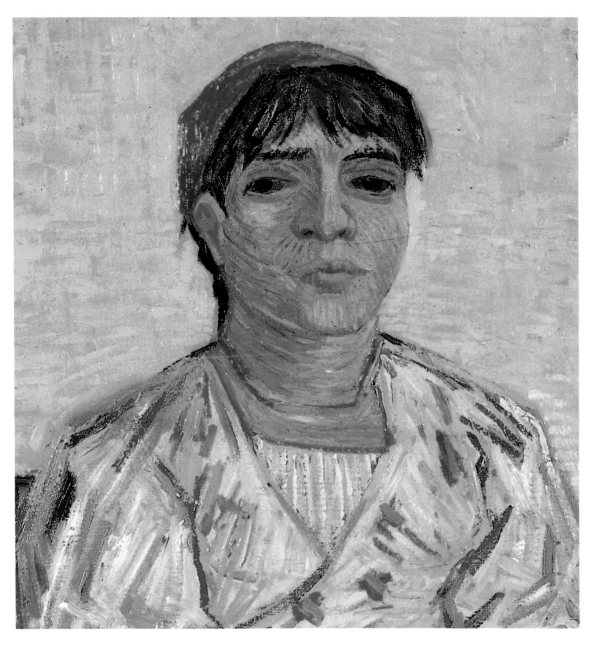

The Italian Woman (detail)

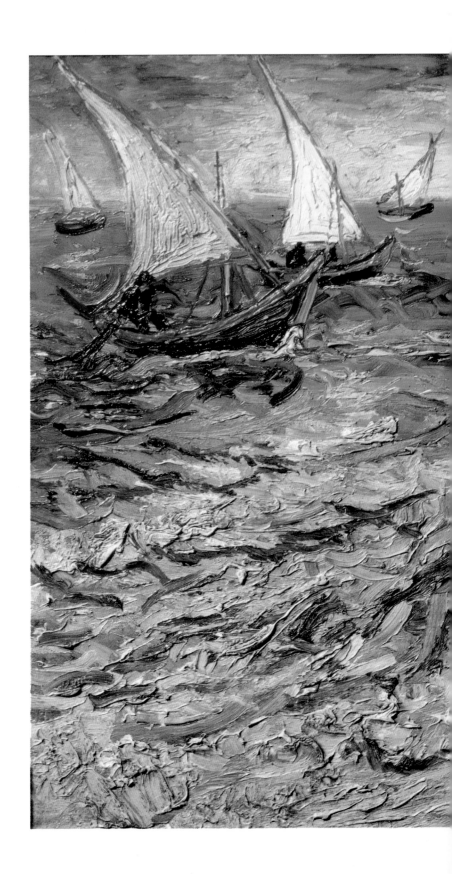

Fishing Boats at Sea

Wheatfield with a View of Arles

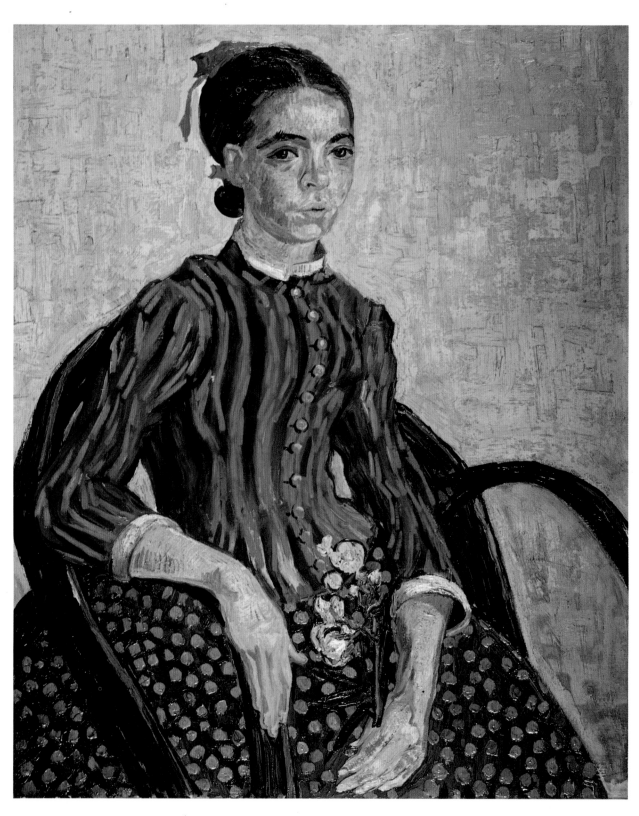

Mousme Sitting in a Cane Chair

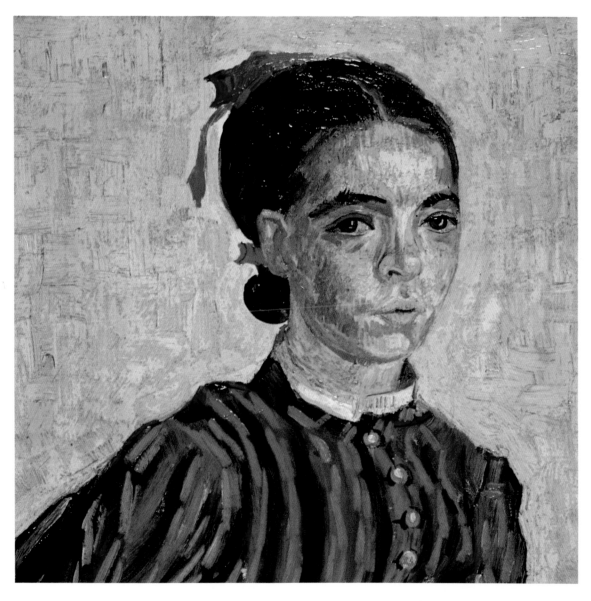

Mousme Sitting in a Cane Chair (detail)

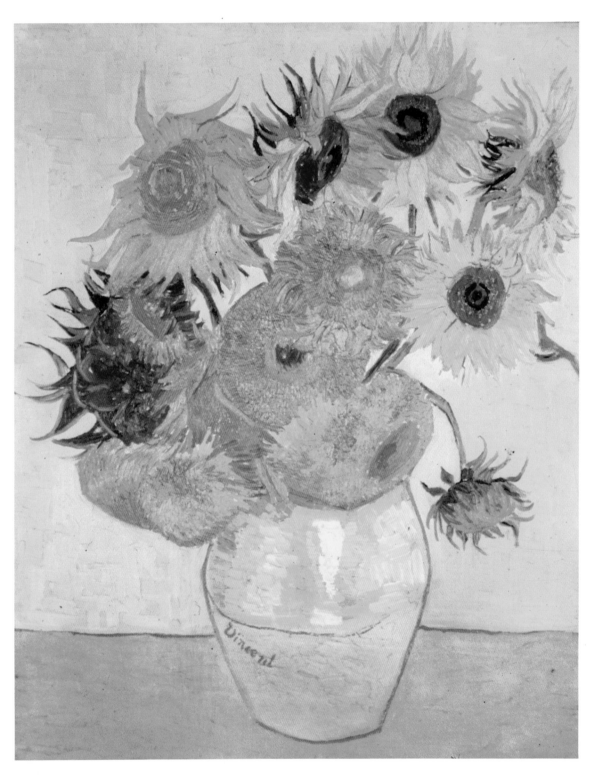

Vase with Twelve Sunflowers

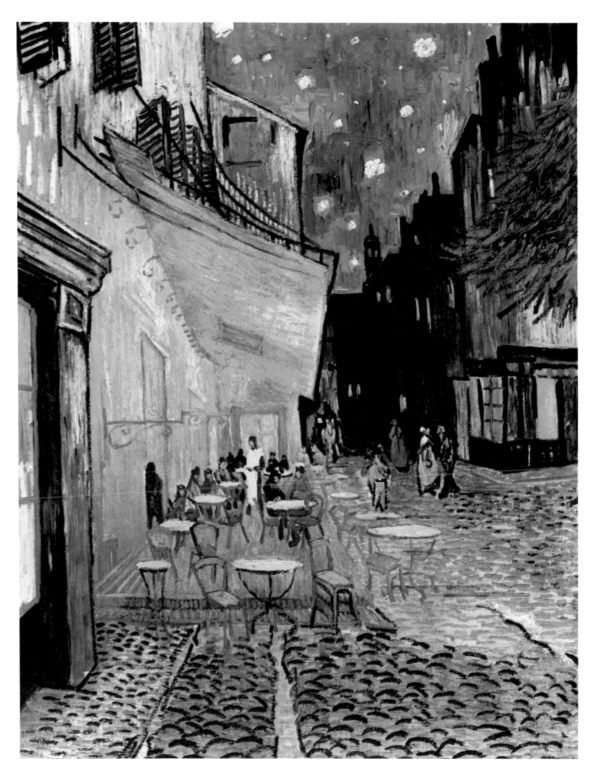

Café Terrace at Night

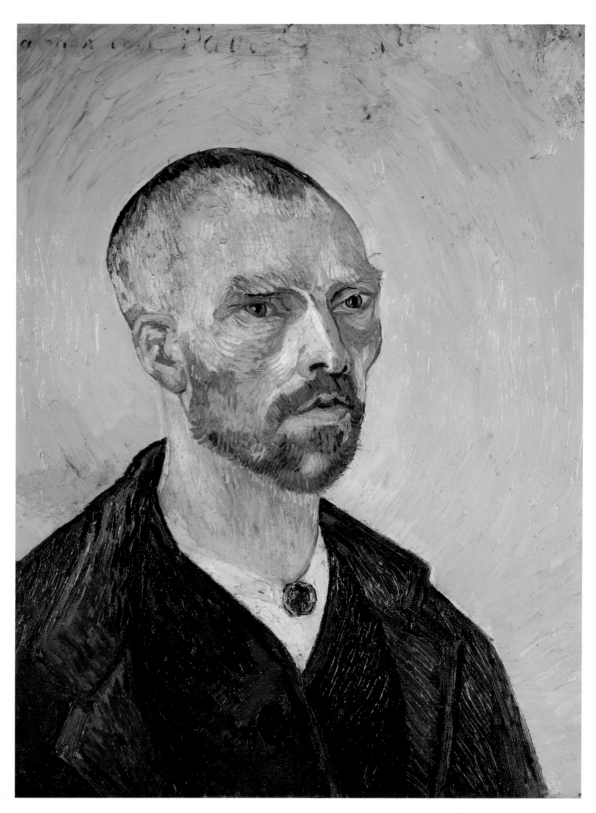

Self-Portrait

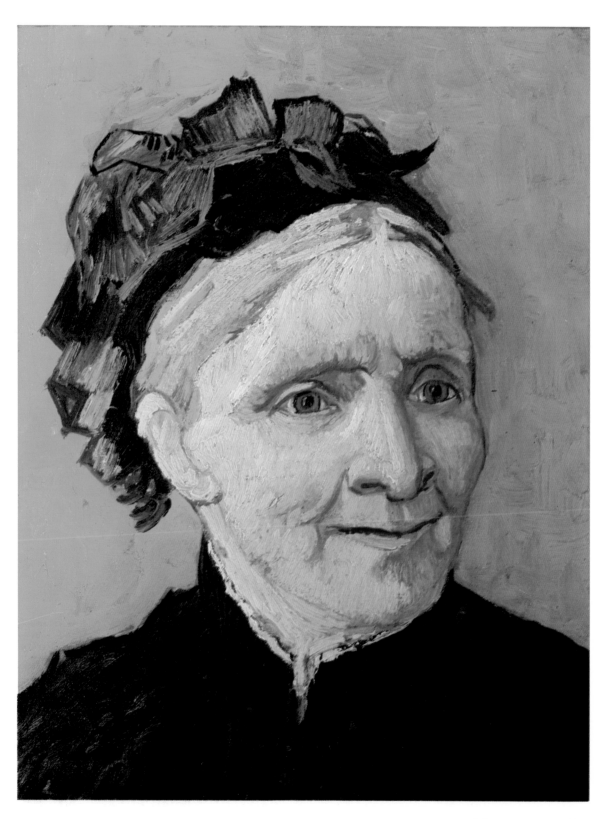

Portrait of the Artist's Mother

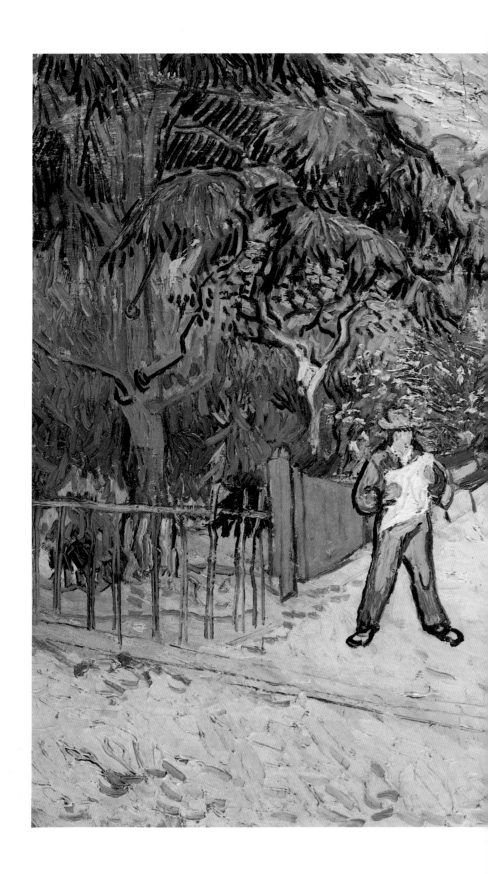

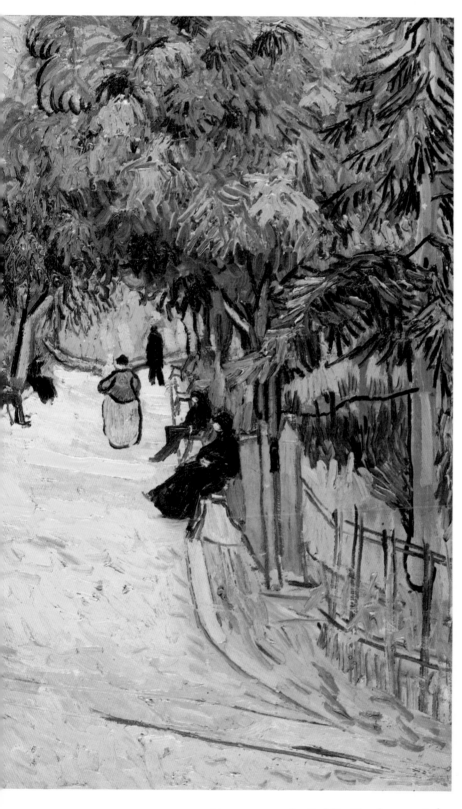

Entrance to the Public Gardens at Arles

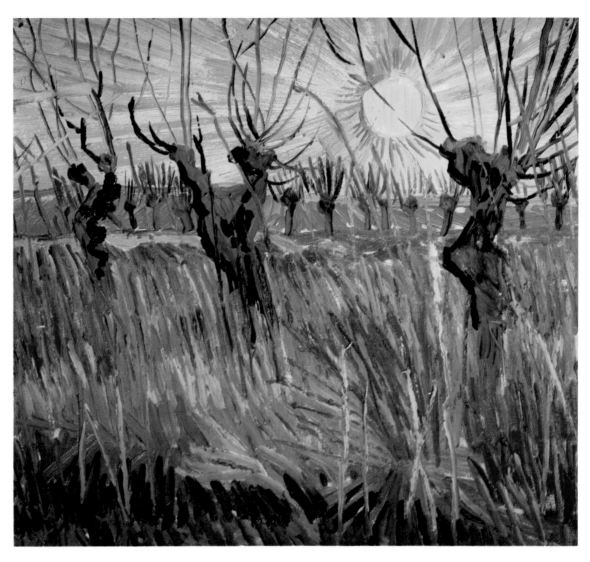

Pollard Willows and Setting Sun

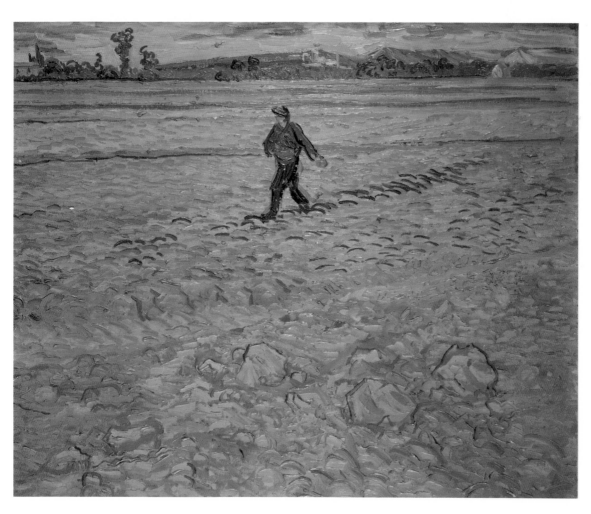

The Sower

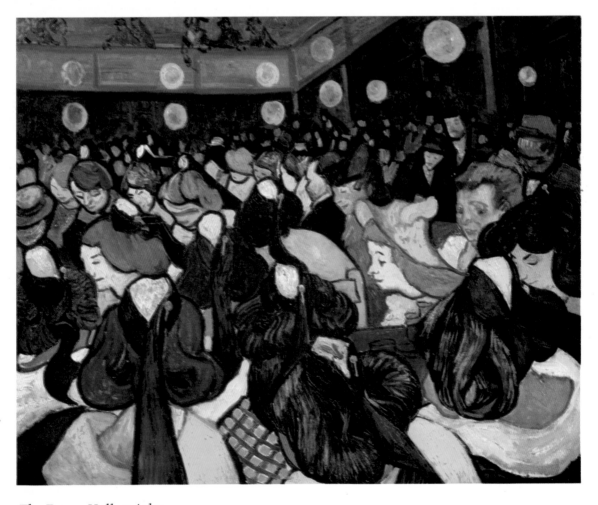

The Dance Hall at Arles

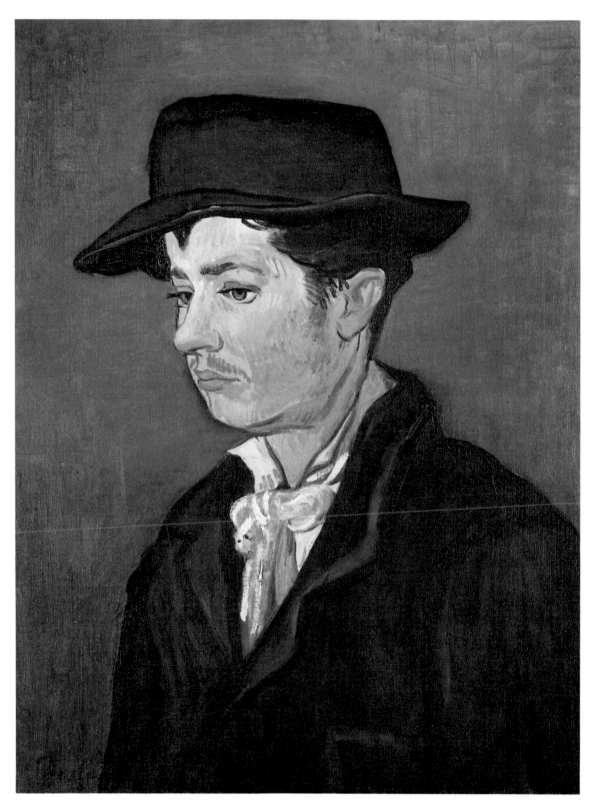

Portrait of Armand Roulin

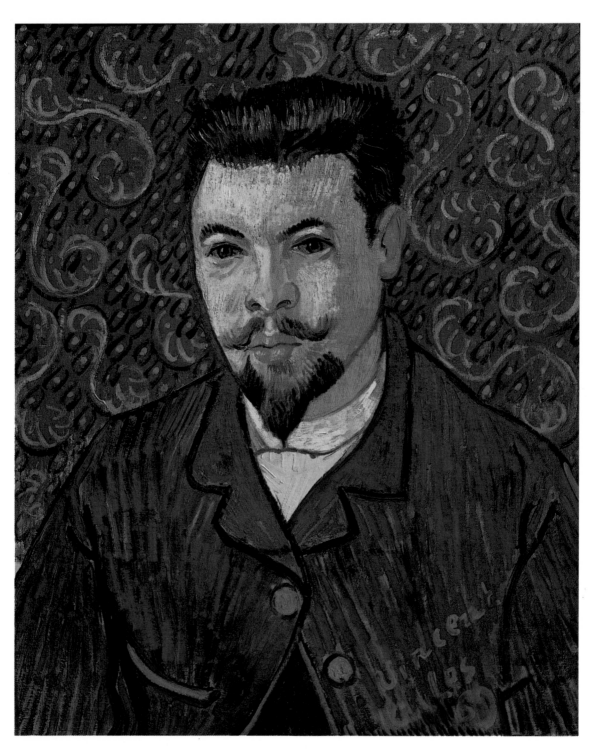

Portrait of Dr. Felix Rey

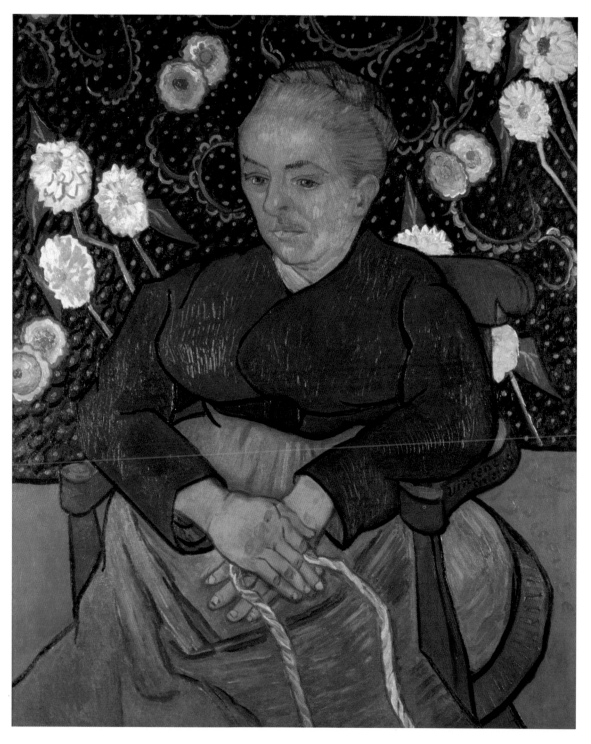

Portrait of Augustine Roulin (La Berceuse)

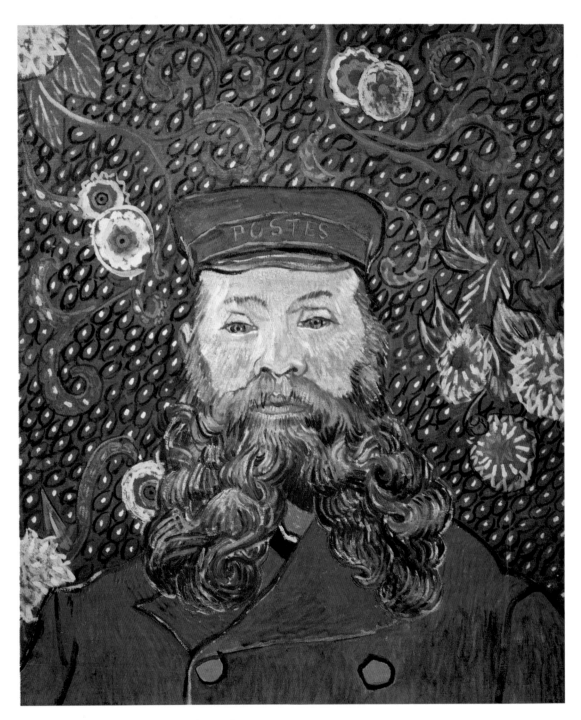

Portrait of the Postman Joseph Roulin

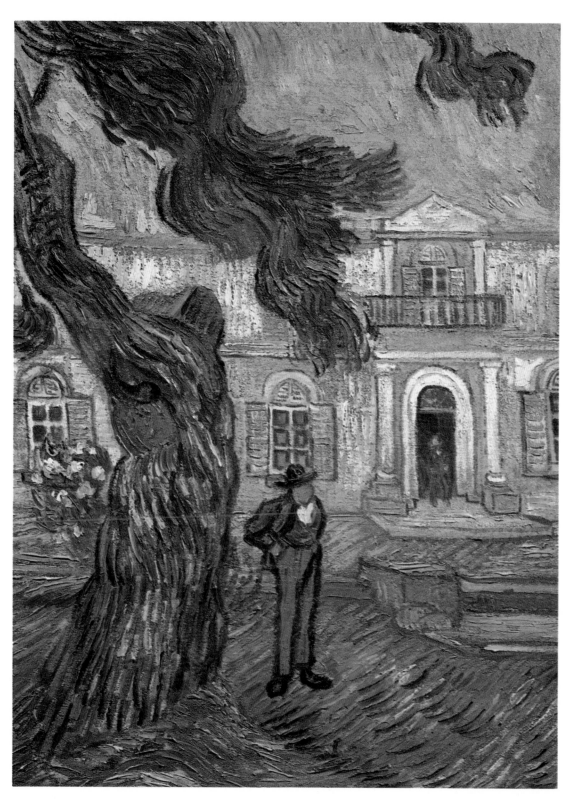

Pine Tree in Front of the Entrance to the Asylum

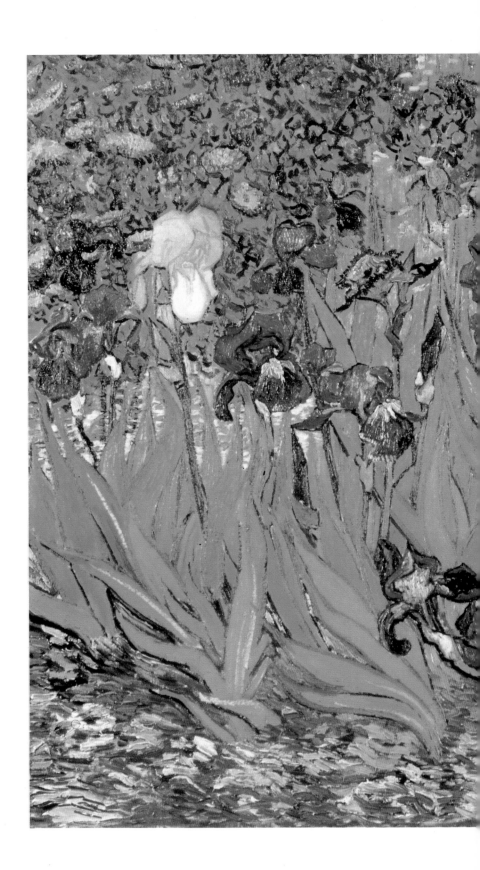

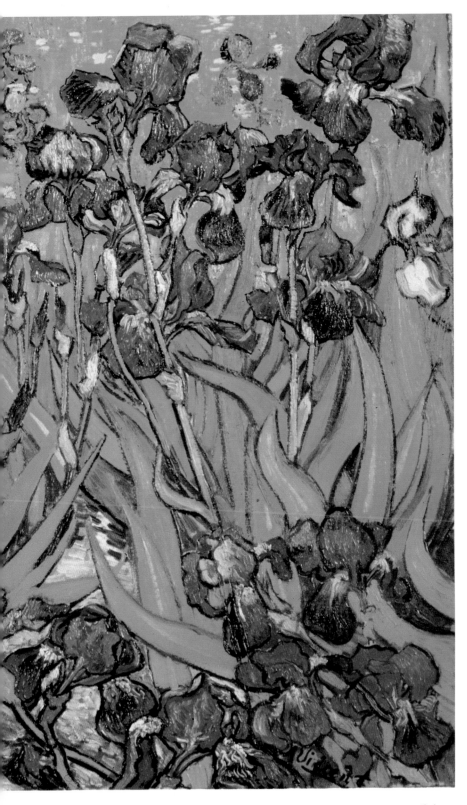

Irises

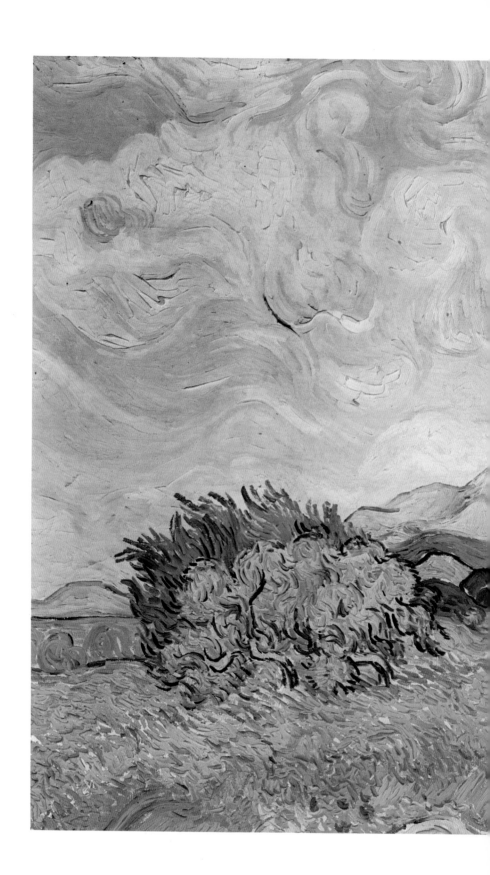

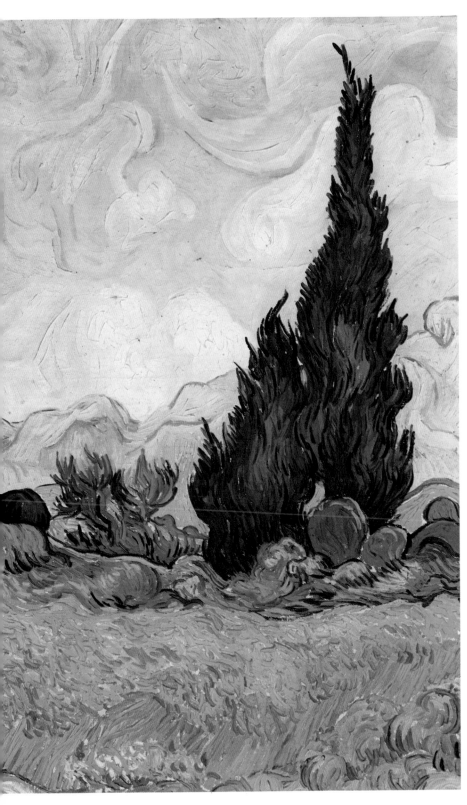

Wheatfield with Cypresses

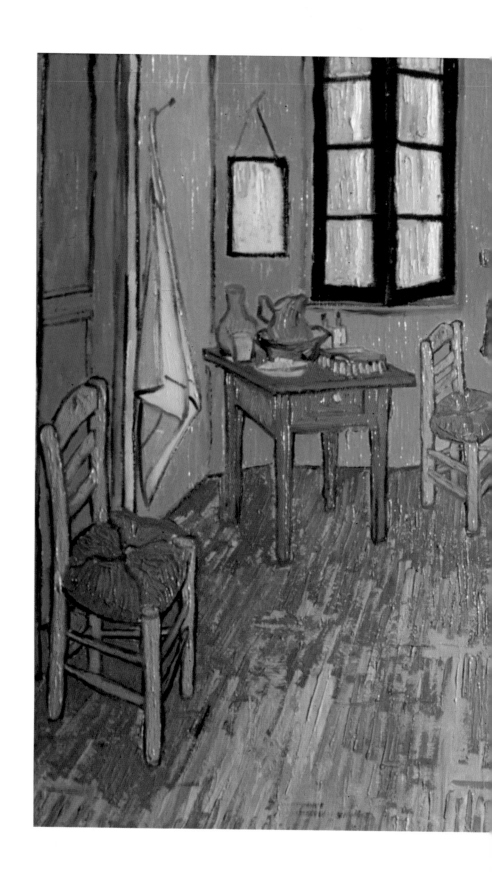

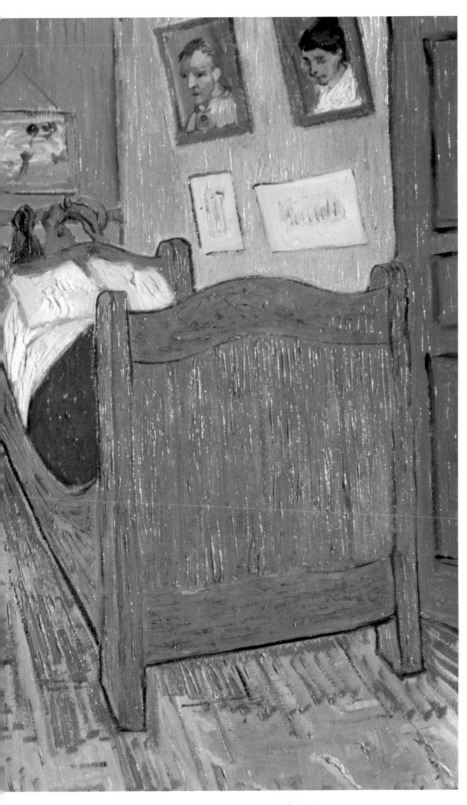

Van Gogh's Room at Arles

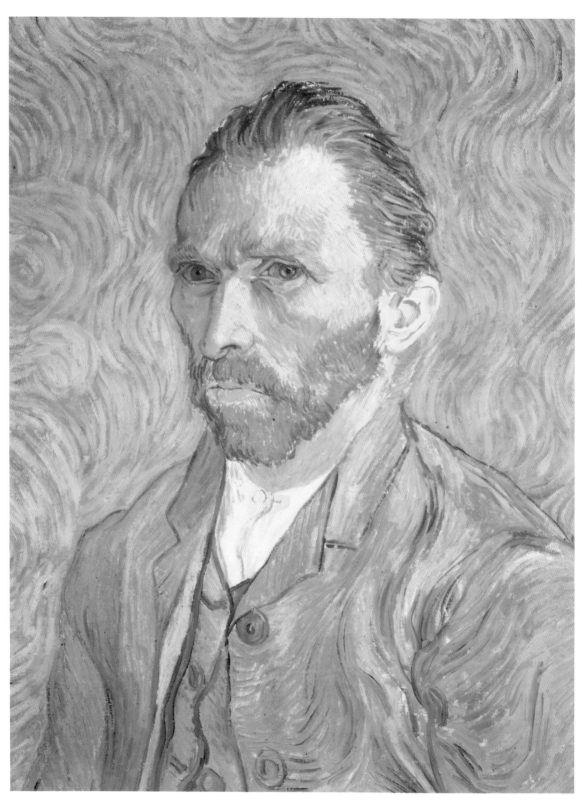

Self-Portrait

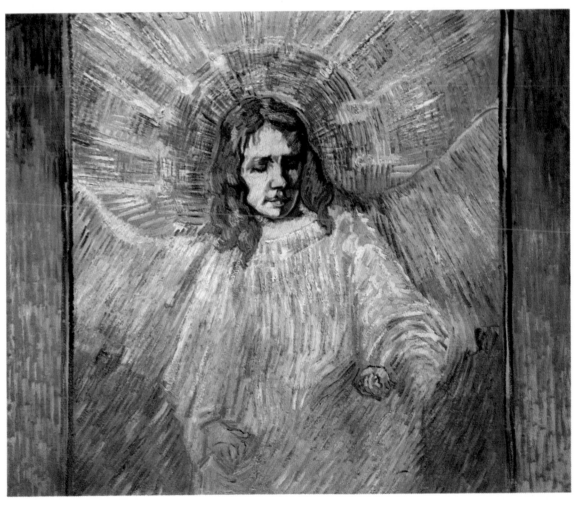

Figure of an Angel

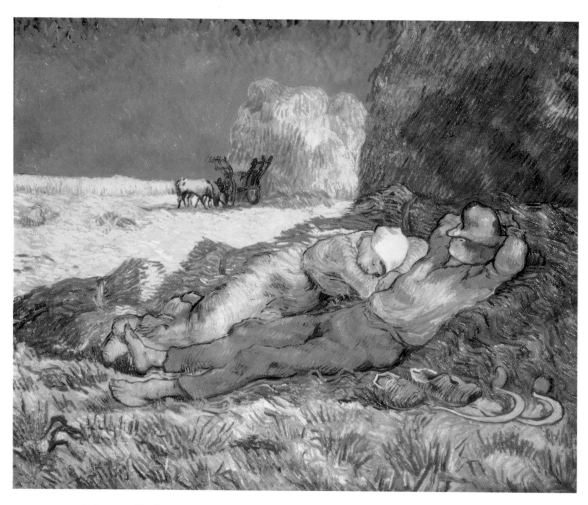

Noon Rest (after Millet)

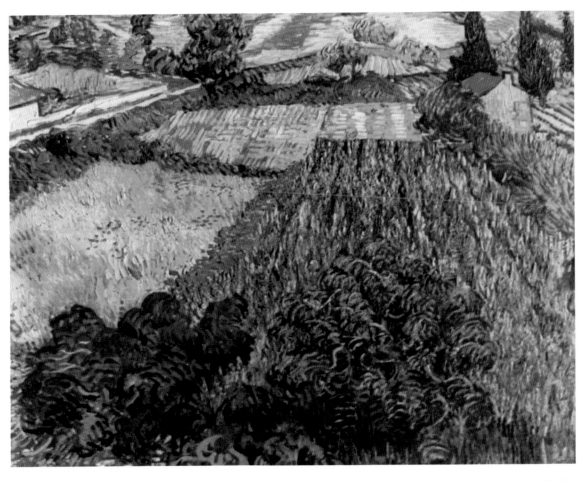

Poppyfields

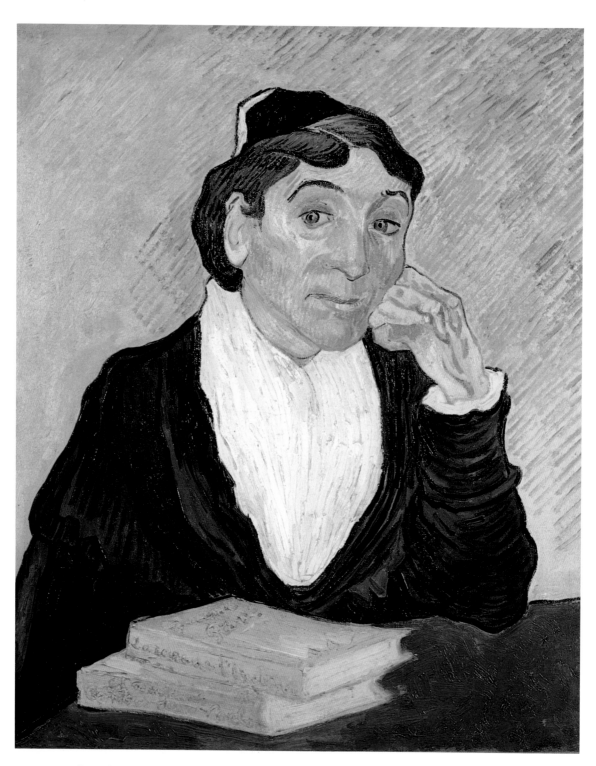

Portrait of Madame Ginoux (L'Arlesienne)

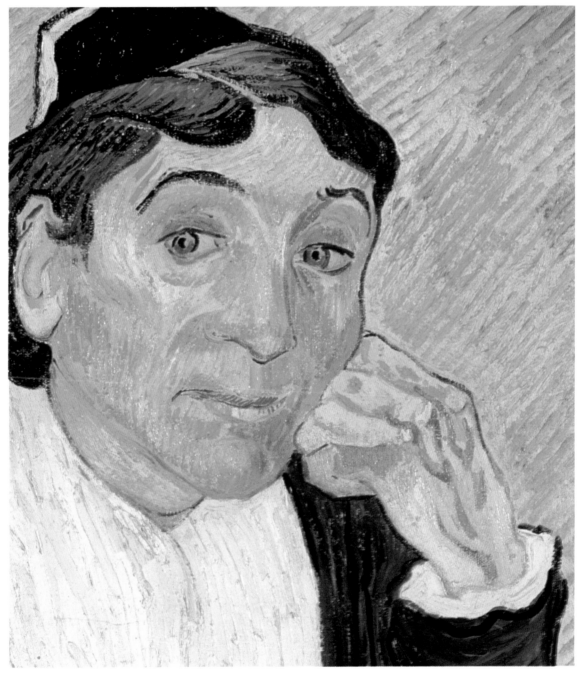

Portrait of Madame Ginoux (detail)

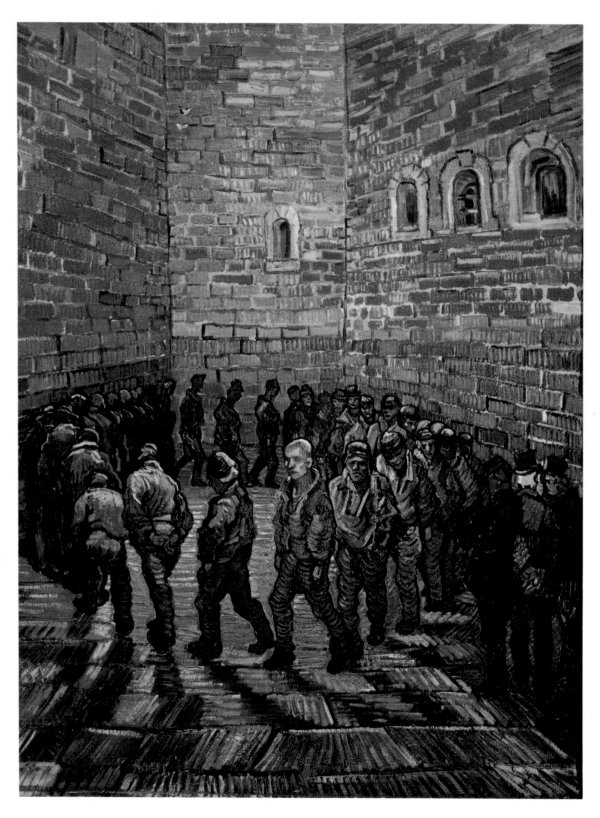

Prisoners' Round

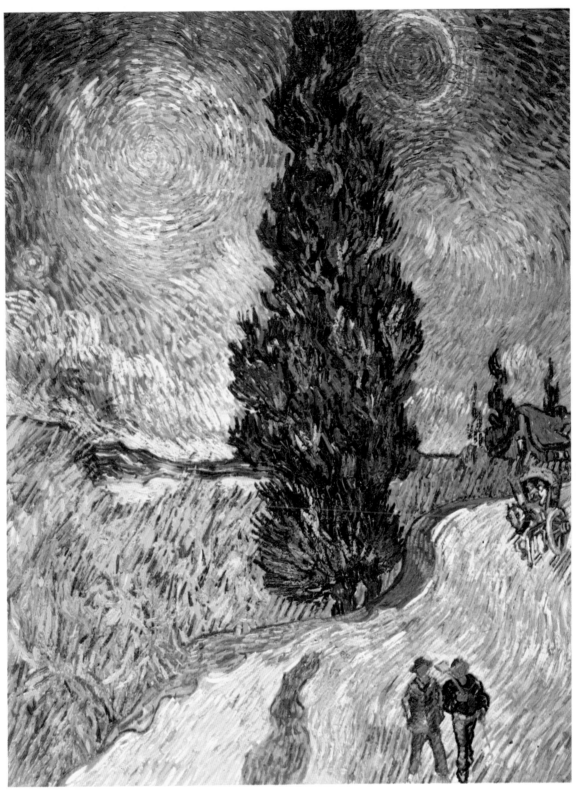

Road with Cypresses

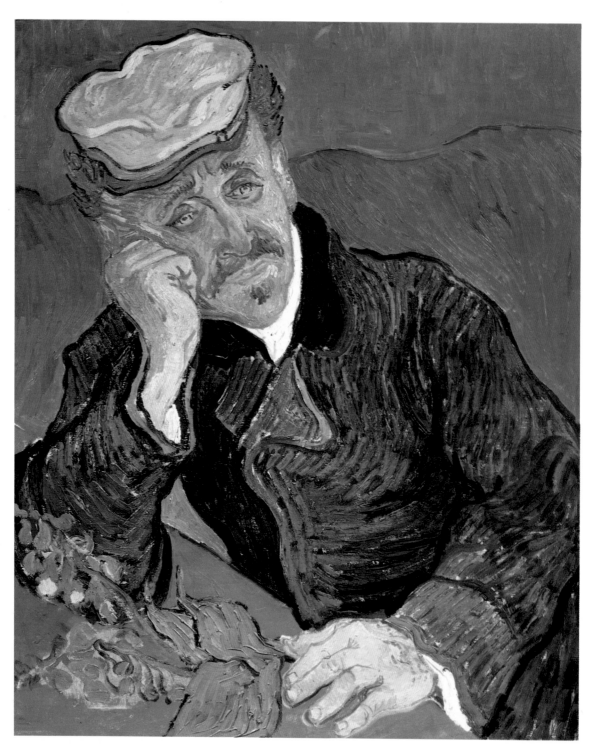

Portrait of Dr. Paul Gachet

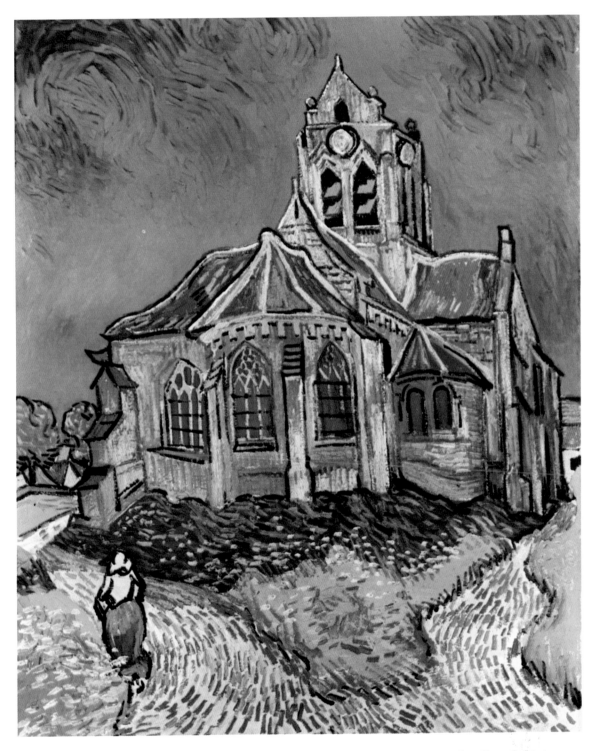

The Church at Auvers

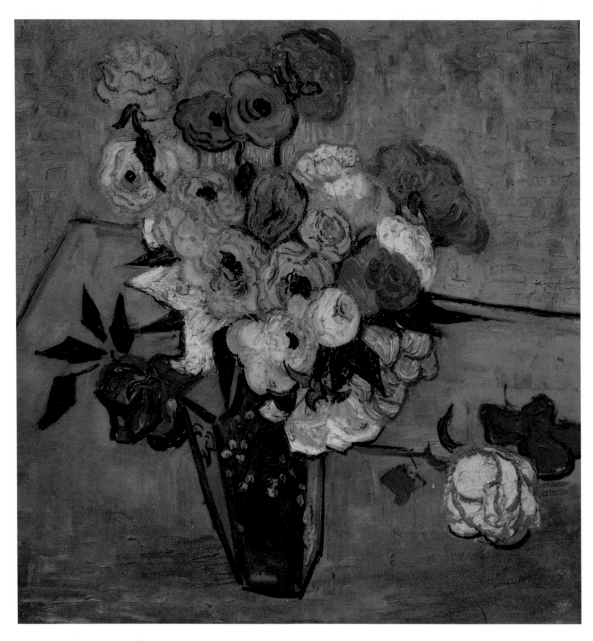

Vase with Roses and Anemones

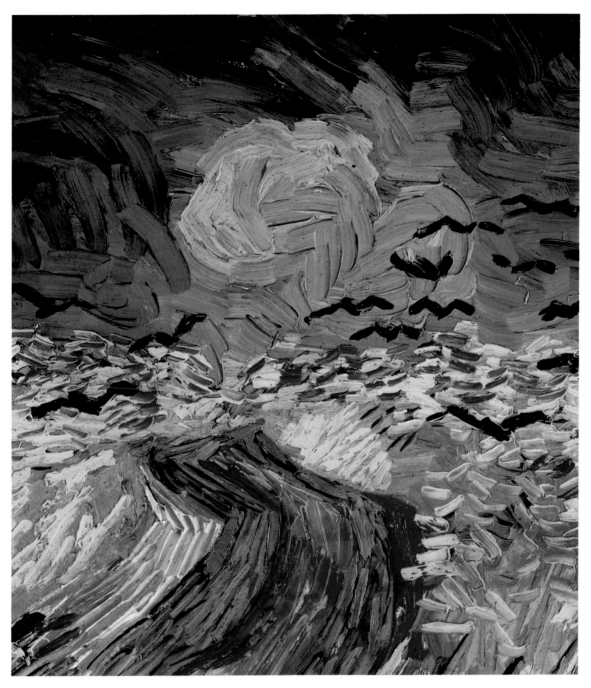

Wheatfield Under Threatening Skies (detail)

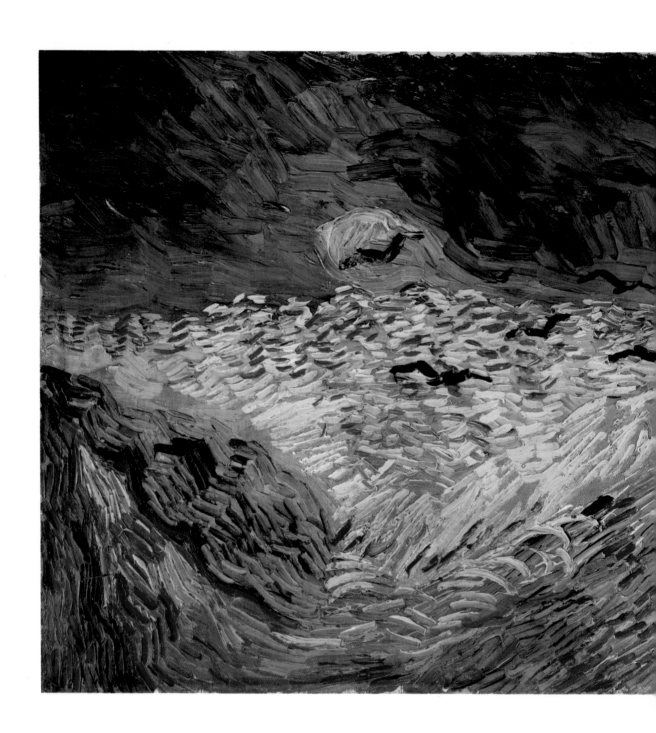

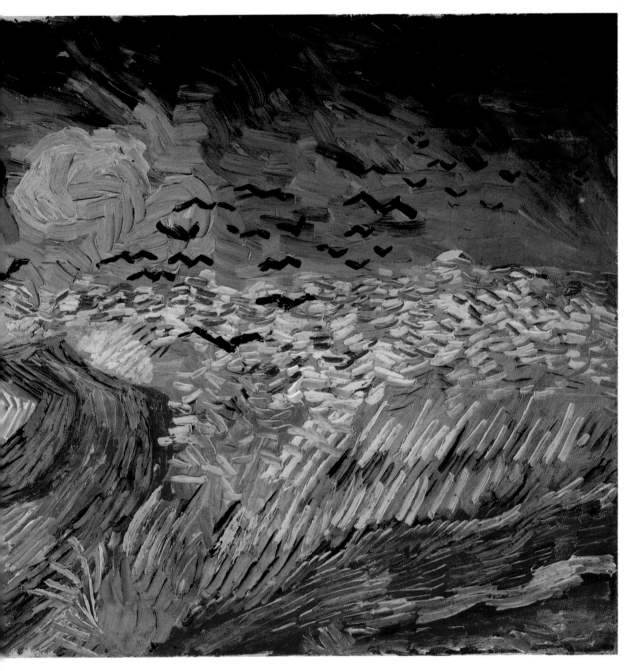

Wheatfield Under Threatening Skies (detail)

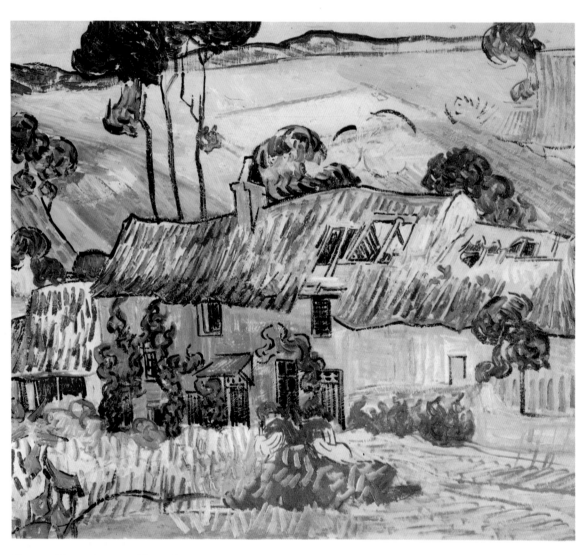

Farms Near Auvers (detail)

Stampa Grafiche Editoriali Padane Cremona